A Collector's Guide to

African Sculpture

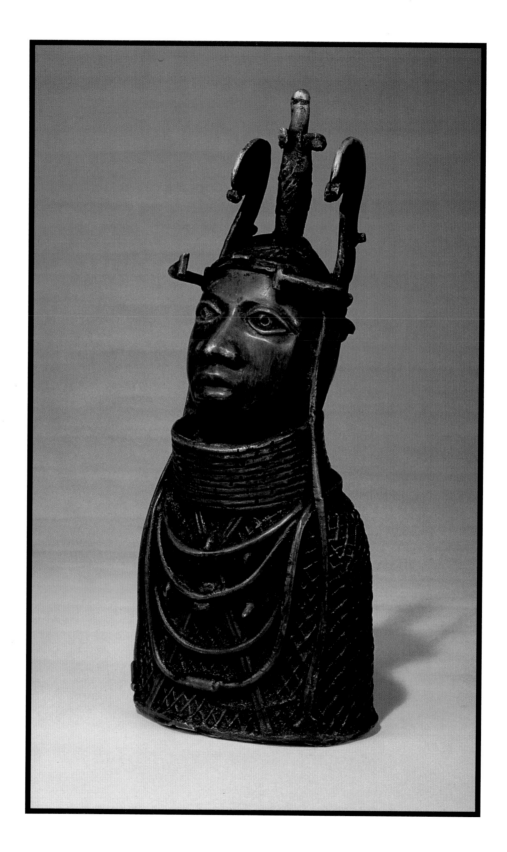

A Collector's Guide to

African Sculpture

Theodore Toatley
&
Douglas Congdon-Martin

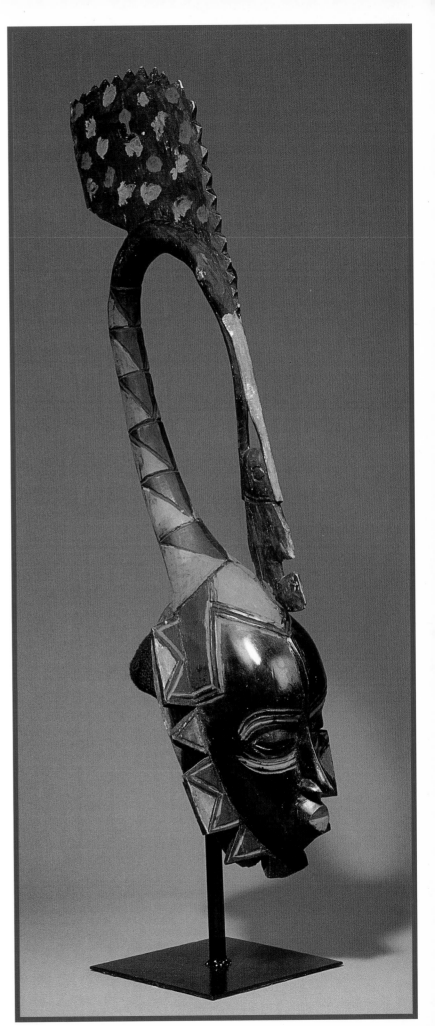

Schiffer Publishing Ltd ®

4880 Lower Valley Road, Atglen, PA 19310 USA

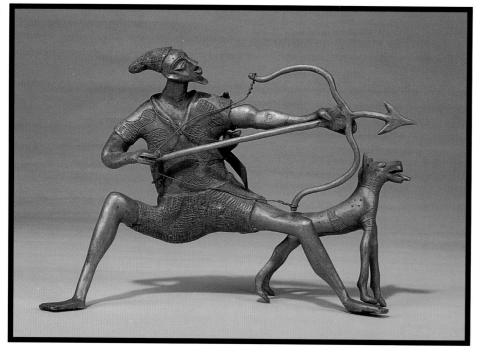

Library of Congress Cataloging-in-Publication Data

Toatley, Theodore.
A collector's guide to African sculpture / Theodore Toatley & Douglas Congdon-Martin.
p. cm.
ISBN 0-7643-1066-6
1. Sculpture, African--Africa, Sub-Saharan--Collectors and collecting. 2. Sculpture, Black--Africa, Sub-Saharan--Collectors and collecting. I. Congdon-Martin, Douglas. II. Title.
NB1091.65.T63 2000
730'.967'075--dc21 99-08649

Designed by Bonnie M. Hensley
Type set in Korinna BT

ISBN: 0-7643-1066-6
Printed in China
1 2 3 4

Published by Schiffer Publishing Ltd.
4880 Lower Valley Road
Atglen, PA 19310
Phone: (610) 593-1777; Fax: (610) 593-2002
E-mail: Schifferbk@aol.com
Please visit our web site catalog at
www.schifferbooks.com

In Europe, Schiffer books are distributed by
Bushwood Books
6 Marksbury Avenue Kew Gardens
Surrey TW9 4JF England
Phone: 44 (0)208-392-8585;
Fax: 44 (0)208-392-9876
E-mail: Bushwd@aol.com
Free postage in the UK., Europe: air mail at cost.

This book may be purchased from the publisher.
Include $3.95 for shipping. Please try your bookstore first.
We are interested in hearing from authors with book ideas on related subjects.
You may write for a free printed catalog.

Dedication

I dedicate the efforts in this book to the two people most influential in my life, my mother and my father.
— Ted Toatley

Acknowledgments

The authors wish to thank Professor Kwaku Ofori-Ansa for sharing his thoughts in the Foreword of this book.

Our gratitude also goes to the Hemingway Gallery in New York City for allowing us to disrupt their business to take photographs of their fine offering in African art.

Finally, thanks to Bonnie Hensley for her design of the book.

Contents

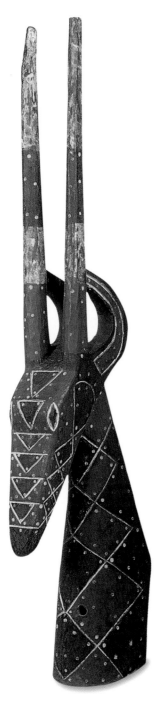

Foreword—6

Introduction—7

Collecting African Sculpture—10

Resources—14

Foreword

Kwaku Ofori-Ansa,
Howard University

Art is central to all aspects of life in traditional African societies. From the prehistory to the present, various art forms have been used to express human spirituality at various stages of the cycle of human life. Beyond the aesthetic values, African art plays a pivotal role in the total sustenance of society. The inherent beauty of African art is, therefore, to be appreciated in the context of its primary role of fulfilling the spiritual and material needs of society. Art and human spirituality, in the African traditional context, are complementary to each other, maintaining a symbiotic relationship. While art serves as a vehicle for the expression of human spirituality, human spirituality gives meaning to art beyond the realm of ordinary human practical living. Each acts in unison with the other to ensure harmony between the physical and the spiritual on both the individual and community levels.

The primary function of art in traditional African societies is, therefore, rooted in the traditional African view of human spirituality, As John Mbiti has aptly noted in his classic book, *African Religions and Philosophies,* the African views the whole of human existence as a religious phenomenon. To the Africa all the elements of the invisible world interact with those of the visible, each speaking to the other, allowing humans to see the invisible universe when they look at, hear, or feel the visible and tangible world. In this context the tangible world of the arts is a vehicle for humanity to see, hear, or feel the invisible universe.

African art displayed in art galleries, museums, or on these pages tell only part of the story; nevertheless, they give the viewer a hint of the complexity and multifaceted functions of African art. A curious viewer is merely standing at the doorway to world where art is more than a controlled arrangement of forms, shapes, lines, textures, and colors. In that world, the spirit of art finds expression in human spirituality and props up a balance between the spiritual and material worlds to sustain the total well-being of the individual and the community.

Introduction

A half century ago one of the early chroniclers of African sculpture wrote that "in spite of the high artistic quality of African objects and their place as products of a virtually ended creative period, their market value is not high. Thus far, only a minority of connoisseurs are aware of the intrinsic expressive power of African art." (Segy, *African Sculpture Speaks,* p. 135)

Much has happened in the intervening 50 years. In America, the civil rights movement sparked a reexamination and renewed appreciation of

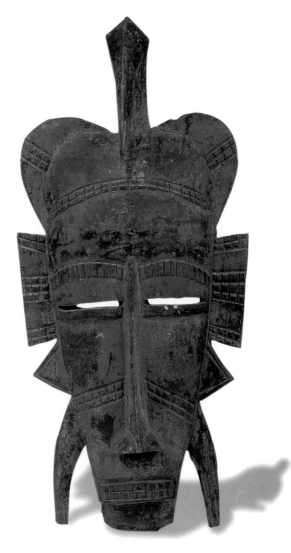

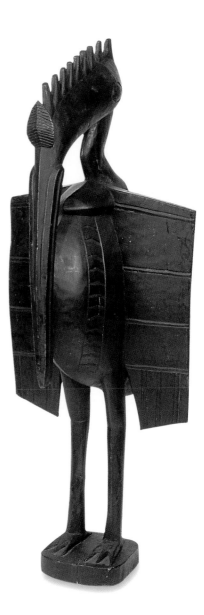

the African heritage. In Africa, nearly all of which was colonized before 1960, independence has extended to even the most intransigent of nations. With it has come both the struggle to forge national identities and the pride of cultural identities recovered and rebuilt. Around the world new technologies of communication and travel have opened links between people, nations, and continents, bringing new appreciation of the variety of cultures, beliefs, and aesthetics which comprise the world.

In the process African art has moved from the dusty bins of the ethnological museum to the well-lighted halls of the art museum. Like many of the great European works of art, African art has its genesis in religious expression. It embodies the stories and spiritual understandings for African people, much as the work of Michelangelo or Raphael did for worshippers in Italy. In both cases what moves the works from mere iconography to art, from ethnological curiosities to artistic masterpieces, is the vision of the artist and the way in which he/she captures that vision on canvas or in stone and wood.

It is the artistry of African sculpture that we celebrate in these pages. While an attempt is made to put the piece in the context of a nation or tribe, and, often, to share the purpose for which it was made, the primary focus is on the work itself. Within the confines of a two-dimensional book we have tried to give the reader a clear look at the sculptor's work; the beauty of the line, the expressive form, the rich colors of wood and paint.

Unlike the art of Michelangelo or other classic European artists, whose art is accessible only in museums and obtainable only by institutions or the very wealthy, the work shown here is from the marketplace. Most other books on African art derive their images from the collections of museums around the world. They are educational and beautiful, but as unobtainable as a work of daVinci. Good African art is available to the collector today. In auctions and through a number of good dealers around the country, the knowledgeable collector can amass a credible and beautiful collection that will represent the breadth and depth of African art. Moreover, they can do so while making a relatively modest investment.

This book is designed to help in that quest. It is broadly organized by the sculpture's country of origin, arranged, roughly, from west to east, beginning with West Africa. The purpose of this is to give a geographical framework to the reader. It is, however, an artificial edifice. The tribal home-lands very rarely fit neatly into the geographical boundaries of the political entity. And sometimes the countries themselves are confusing, as in the countries of Congo and the Republic of Congo. The advantage of working geographically rather than tribally is that the reader can see affinities not only within a people's work, but with nieghboring peoples as well.

The factual information about the countries of sub-Saharan Africa has been gleaned, in large part, from an excellent resource out of the University of Iowa. The Art and Life in Africa Project has produced both a CD-ROM and a website with a wealth of material concerning Africa, including national histories and tribal portraits, along with extensive essays and analysis. Both were developed by L. Lee McIntyre and Christopher D. Roy. The CD-ROM is entitled *Art and Life in Africa: Recontextualizing African Art in the Cycle of Life* and the website is "Art and Life in Africa Online," http://www.uiowa.edu/~africart/ (the date you use the site). See the resources for more information.

We hope that you will find this a useful as well as beautiful book. That the sculpture of Africa has the power to move us aesthetically and emotionally, is a testament to the people and the artists who brought it into being.

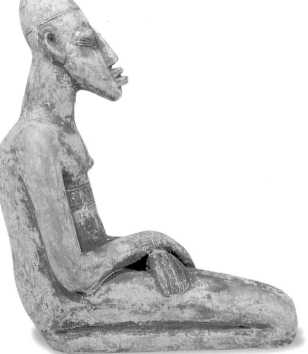

Collecting Afri

Very few collectors of African sculpture actually travel to Africa, instead finding the works in American galleries or shops. Even if they are fortunate enough to travel to Africa, collectors are more likely to buy sculpture from a dealer in a large city marketplace, than in the village where the work originated. Despite improvements in transportation, the inland villages remain relatively inaccessible to the casual tourist.

By necessity, then, the collector must bring a considerable amount of knowledge and trust to the purchasing decision. It is hoped that this book will be a help in that process.

Form & Function

Frank Willett has suggested that there are two ways to look at African art: form and function. African sculpture rises out of the context of the community and its belief system. Most of it has a purpose in the life of the village or tribe. Masks are carved to be worn in a dance, where they represent or, more accurately, embody a spiritual entity. In the same way, statues *are* the ancestor spirits present and avail- able to the living, or embody spirits that heal, guard, and protect. For collectors, whatever knowledge they can gather about the function of their sculpture will enrich their appreciation of the work. While it is hoped this book will help increase that knowledge, other books focus more completely on the context of the art, and museum exhibits are wonderful ways to deepen the understanding of the sculpture's function. For some collectors this is the primary focus of their collection.

For others, though, the appeal of African sculpture lies in its beauty. While it is certainly inadvisable and probably impossible to separate African sculpture from its context and function, the beauty of the work

can Sculpture

alone is enough to capture the eye and heart of the collector. This is why African sculpture was so influential in the history of modern art. According to Frank Willett, a revolution in twentieth century art began with a rather average mask given to Roger Vlaminck in 1905. He sold it to the artist Andre Derain, who was overwhelmed by its power and beauty. Derain showed it to Picasso and Matisse, before it was borrowed by Ambroise Vollard for casting. Another artist, George Braque, told of the "new horizon" that African masks opened for him. (*African Art*, pages 35-36. Willett has a photograph of the revolutionary Fang mask on page 37 of his book.)

For these European artists and for many of today's collectors, it is the essential aesthetics of African sculpture that enthralls. Like all art, it is a reflection of the vision, creativity, and skill of the artist. Ironically, in earlier times the artist rarely entered into the discussion of African art. In part this was because of the way the art was, and still is, gathered. After the European "discovery" of African art, traders made their way to distant villages, returning with large loads of carvings. They rarely brought out any information that could enrich the knowledge of the collector. The carvers were thought to be anonymous folk artists, exercising their craft by rote, following the formulae and traditions of hundreds of years of tribal life.

Only in recent years has this attitude begun to change. We now know that the carver is usually in a respected position in the tribe, attained only through years of apprenticeship. We also know that, while the carvings are done in the context of the community and its traditional forms, each carver has his (they are almost exclusively male) own unique style and vision. Sometimes an individual artistic innovation will bring significant changes to traditional forms, that are passed to future generations of carvers. The work of

the individual artist is recognized and appreciated by those in the community for its particular vision and artistic skill. Slowly the larger world is beginning to recognize the names and styles of the carvers, though it is still a rarity to find a piece so identified.

The interpretations of the human and animal form, the abstractions, the visual power…as in any work of art, these elements have the power to move the viewers. They wonder at the ability of the artist to see the world in such a fresh and creative way. They recognize some of the archetypes that are common to the human species. They marvel at the flowing line, rich texture, and sometimes wild, sometimes subtle color of the of the work.

Authenticity: Age, Use, & Form

For the collector of African sculpture the concept of authenticity requires some explanation. The truth is that because of the fragile nature of wood, the harsh African climate, and the tenacity of the African termites, nearly all of the wooden sculpture and masks that reach the marketplace today date from the twentieth century, and most to the last 50 years. Indeed, when you ask a dealer if a piece is old, he would not be deceiving you if he said yes to a piece dating from the first half of the twentieth century. Art work that was removed from the continent by explorers in the nineteenth century is now found primarily in museums or among some of the finer collections. With the exception of some bronze or terracotta pieces, age is not a good indicator of authenticity.

More commonly, authenticity is measured by use. To put it bluntly, some masks were made for use and some for sale. Though like the rest of the world Africa has become more and more secularized, traditional dances and ceremonies are still practiced. There are still masked dancers who mark the rites of passage. There are still those who recommend the use of fetishes to solve problems of health or relationship. For the collector a mask that has been "danced" or a fetish that has actually been used has an authenticity that is worth a premium.

Determining whether a piece is authentic or not is not a task one learns easily, however. Of course you should look for the normal indicators such as wear marks and patina, as well as evidence of ritual use such as encrustation of pigment or blood. Unfortunately most of these can be and are later added to a piece to give it the aura, if not the reality, of authenticity.

As with other art forms, the best assurance of authenticity is a good provenance. It is important to find dealers you trust, who will tell you

how they acquired a piece, its origins and purpose, and why they believe it is authentic. Most dealers love what they are doing and want you to love what you purchase. They will pull out a pile of reference books to show you similar examples. They will point out features that are unique to the artwork and will help you to appreciate it even more.

Beyond age and use, there is an authenticity of form. The reality is that much of the carving that is currently exported from Africa is carved to meet the growing demand from collectors. Much of it is mass produced with little thought to tradition, craft, or beauty. Such works will find their way into import stores and, later, into the decorating schemes of American apartments. While some of these carvings reflect traditional forms, however poorly executed, much of it is purely fanciful, lacking both art and tradition. The collector should give wide berth to these objects.

On the other hand it is important not to dismiss "undanced" works out of hand. Some of the same carvers who produce masks for the dance and sculptures for tribal use are also creating objects for the marketplace. Often they bring to these objects the same skill, vision, and artistry as they do to tribal objects. They may reflect traditional forms or they may step into new territory. Whichever is the case, they bring to the work the same talent and vision, creating works of art that are "authentic" in their own right. As Ladislas Segy wrote many years ago, "As old as a piece may appear, ultimately it is the *talent* of the carver that gives artistic quality to an object and makes a piece desireable to an art lover." (*African Art Speaks*, page 133).

At the same time the collector should remember that there is a premium to older, authentic works. They are much sought after and worth more in the marketplace.

Values

Pieces are identified by function, material, size, tribe and nation. In addition a price range will be provided for most pieces. The price shown is for the actual piece shown, and is based on prices found in the eastern United States. Several factors go into the pricing and will account for variations for similar pieces you may find in the marketplace. Unlike mass-produced collectibles, it is important to remember that these are unique works of art. The artistic merit of the piece, including the skill of the artist, will affect the price the most. This factor will be followed by age, condition, and rarity of form. Prices will further vary depending on the area of the country in which you are shopping. In short, while the prices shown will help the reader estimate the relative value of a piece, each piece will still have to be evaluated on its own merit.

Resources

Museums

Most major university museums and public art museums have collections of African sculpture and art. These are of particular interest:

National Museum of Africa Art
950 Independence Avenue, SW
Washington, D.C. 20560
Phone: 202.357.4600
Website: www.si.edu/nmafa

The Museum of African Art
593 Broadway
New York, NY 10012
Phone: 212.966.1333
Website: www.africanart.org

Afrika Museum
Postweg 6
6571 CS BERG EN DAL
Netherlands
Phone: 024-6841211
Website: www.afrikamuseum.nl

The Stanley Collection at the UI Museum of Art
University of Iowa
Iowa City, IA 52242
Website: www.uiowa.edu/~africart

Publications

There is a wealth of written materials available to the collector. Below is a short list that will be of particular use and interest. Some of these are referenced in the captions by abbreviations as follows:

Segy, ASS: Segy's *African Sculpture Speaks*
Segy, MBA: Segy's *Masks of Black Africa*
Willett, AA: Willett's *African Art*

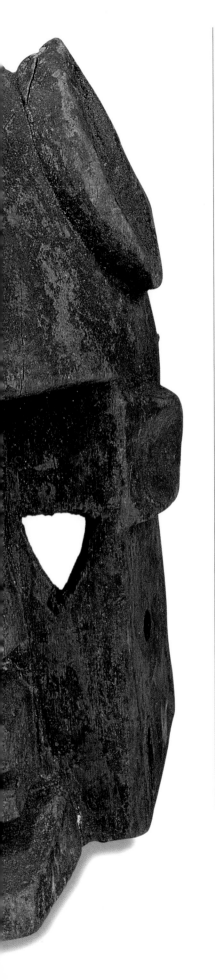

African Arts Magazine.

Cole, Aniakor. *Igbo Arts: Community and Cosmos.* Los Angeles: Museum of Cultural History, University of California at Los Angeles, 1984.

Fagg, William. *Nigerian Images: The Splendor of African Sculpture.* New York: Frederick A. Praeger, 1963.

Gillon, Werner. *A Short History of African Art.* New York: Penguin Books, 1984.

Herold, Erich. *Tribal Masks.* London: Paul Hamlyn, 1967.

Huet, Michel. *The Dances of Africa.* New York: Harry C. Abrams, Inc., 1996.

Lenzinger, Elsy. *The Art of Black Africa.* Greenwich, CT: New York Graphic Society, Ltd., 1972

Mack, John. *Masks and the Art of Expression.* New York: Harry Abrams, 1994.

Meauze, Pierre. *African Art.* Cleveland: The World Publishing Company, 1968.

Pace Gallery. *African Accumulative Sculpture.* New York: Pace Gallery, 1974.

Pauline, Denise. *African Sculpture.* New York: Viking Press, 1962.

Phillips, Tom, editor. *Africa: The Art of a Continent.* New York: Prestel, 1999.

Robbins, Waren M. and Nancy Ingram Nooter,. *African Art in the American Collection.* Washington: The Smithsonian Institute, 1989.

Ross, Doran H. "Carnival Masquerades in Guinea-Bissau," *African Arts* Vol xxvi, Number 3, July, 1993. Los Angeles: UCLA, 1993.

Roy, Christopher D, and L. Lee McIntyre. *Art and Life in Africa: Recontextualizing African Art in the Cycle of Life. Vers. 1.0.* Iowa City: The Art and Life in Africa Project, 1998.

Segy, Ladislas. *African Sculpture Speaks, 4th Edition.* New York: Da Capo Press, 1975.

_____. *African Sculpture.* New York: Dover Publications, 1958.

_____. *Masks of Black Africa.* New York: Dover Publications, 1976.

Sieber, Roy, and Roslyn Adele Walker. *African Art in the Cycle of Life.* Washington: The Smithsonian Institution Press, 1989.

Underwood, Leon. *Masks of West Africa.* London: Alec Tiranti, 1964.

Willett, Frank. *African Art.* New York: Thames and Hudson, 1985.

Website:

McIntyre, L. Lee and Christopher D. Roy. "Art and Life in Africa Online." 1998: The Art and Life in Africa Project, http://www.uiowa.edu/~africart/ 11.17.1999.

GUINEA BISSAU

With a population of 1.1 million people, this western African nation is slightly over 36,000 miles in area. Major tribal groups include the Balanta, Fulani, Madinka, Manjaca, and Papel. Over half the population practices African religion, a third are Muslim, and the remainder are Christian. The Portuguese explored this area in the fifteenth century, establishing a limited number of trading outposts until the growth of the slave trade in the 1600s. In the nineteenth century, when slavery declined, Guinea Bissau became a major commercial center. Independence came in 1974.

Based on information from the University of Iowa, Art & Life in Africa project.

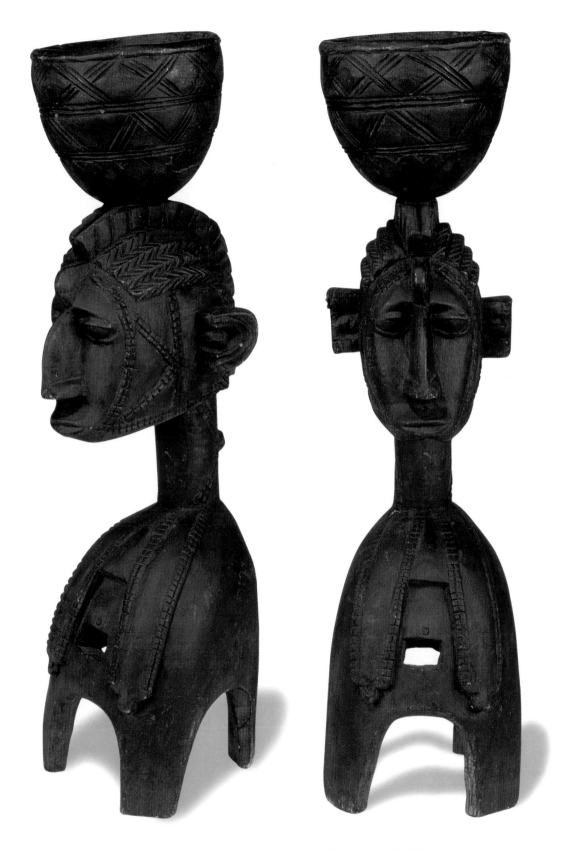

Medicine holder in the form of the *nimba* fertility
figure shoulder mask. $350-450.
Wood, 26" h
Baga People
Guinea Bissau

Anok, an abstract head with human and bird features, including feathers and beak. Used in agrarian and funeral rituals. $800-900.
Wood, 27" high, 42" long
Guinea Bissau

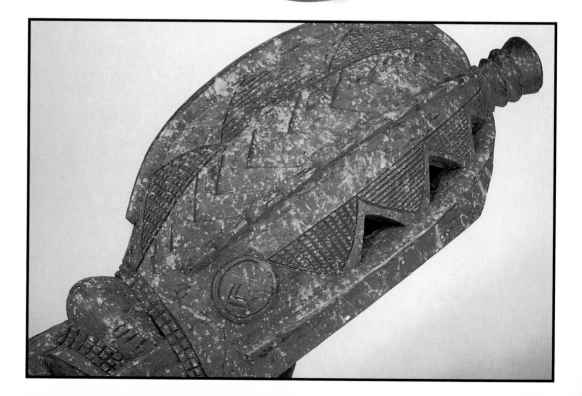

SIERRA LEONE

Nearly 5 million Sierra Leoneans live in this West African country. Principal tribal groups are the Krio, Temne, Mende, Vai, and Kru. Sixty percent of the country practices African religions, thirty percent Muslim, and ten percent Christian. Sierra Leone had early contact with the Europeans and became one of the first English colonies on the continent. In 1787 the British established Freetown as a settlement for freed slaves. Since they came from many locations, the former slaves adopted English traditions as their common heritage and blended the traditions of several West African cultures to create a unique identity. Freetown became a center of trade. Independence came in 1961.

Based on information from the University of Iowa, Art & Life in Africa project.

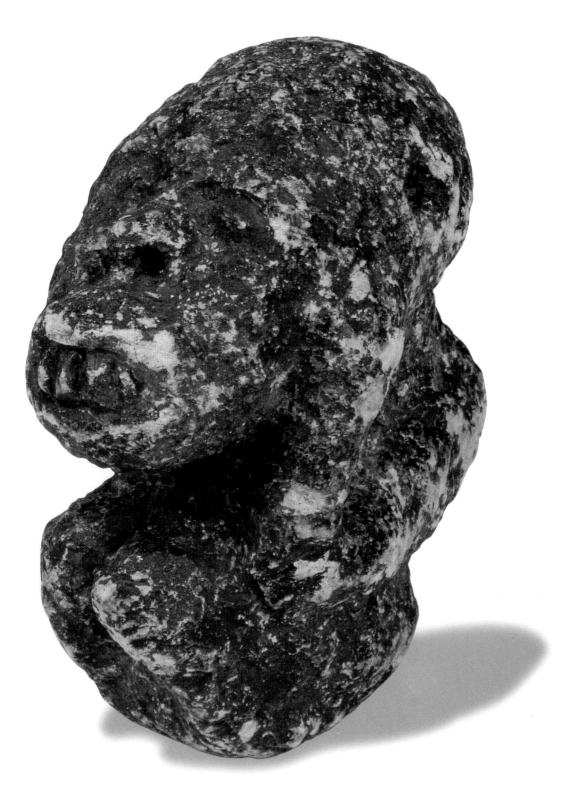

Nomori (nomoli) figure. Placed in the field to ensure prosperous crops. Some stories tell of the Nomori going off to steal plants from other fields. If they did not succeed, they were beaten. (*Willett*, p. 98). $600-700.
Soapstone, 6" h.
Mende People
Sierra Leone

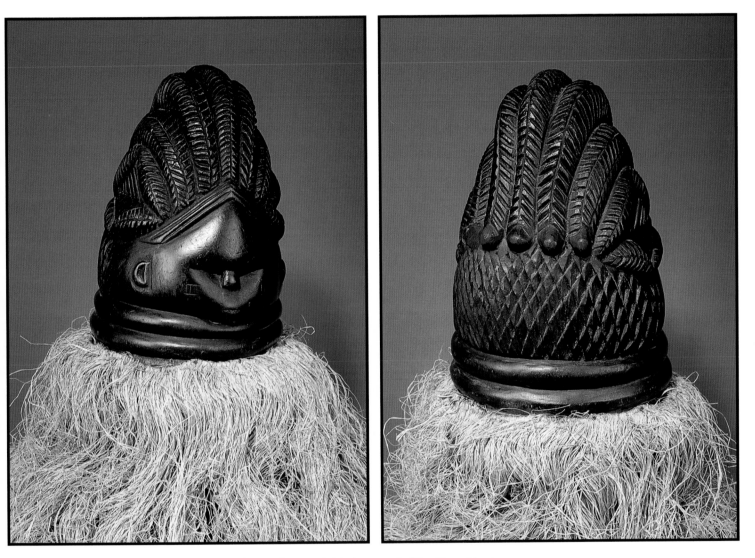

Sowei Society initiation mask. The Sowei took
girls in as they approached puberty and in-
structed them in their adult duties. The "fat
rings" at the neck may symbolize the maturation
into adulthood. $800-900.
Wood and fiber, 13", mask only
Mende People
Sierra Leone.

LIBERIA

Historians think that Liberia was settled through migration from the north and east between 1100 and 1600 AD. Descendants of these early residents continue to inhabit Liberia, including the Kpelle, Bassa, Gio, Kru, Grebo, Mano, and Dan peoples. European contact and trade began in the mid-fifteenth century. In 1822, the United States sought a place for freed slaves to settle on the African continent. Following the lead of the English in Freetown, Sierra Leone, they negotiated with tribal leaders in Liberia and established Monrovia, named for then President James Monroe. The nation of Liberia was formed in 1838, under US governance. Independence came in 1847, the first colonial African state to regain their self-government. Currently the population of Liberia is slightly over 3 million, seventy percent of whom practice African religion, twenty percent Muslim, and ten percent Christian.

Based on information from the University of Iowa, Art & Life in Africa project.

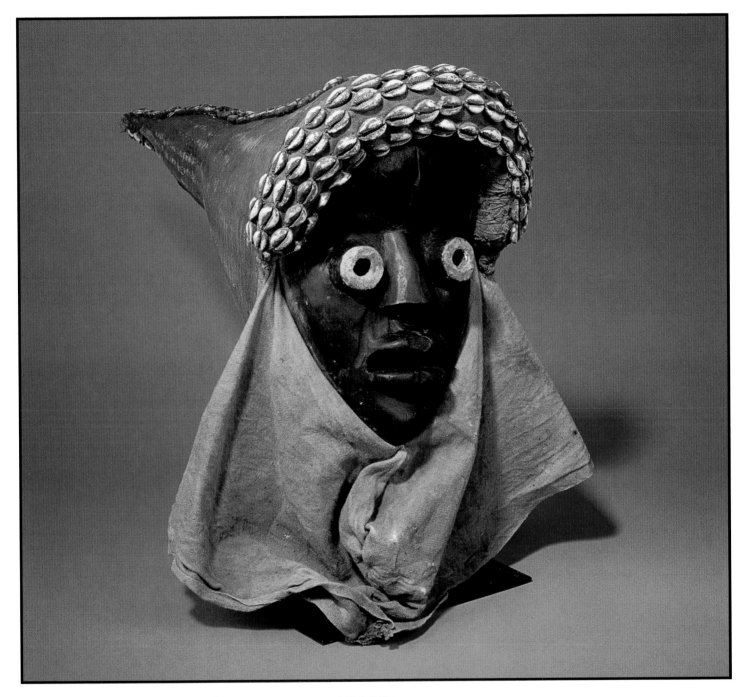

Face mask with headdress. $400-500.
Wood and cowry shells with a superstructure of fabric, 19" x 10" x 25"
Guere-Ouobe People
Liberia

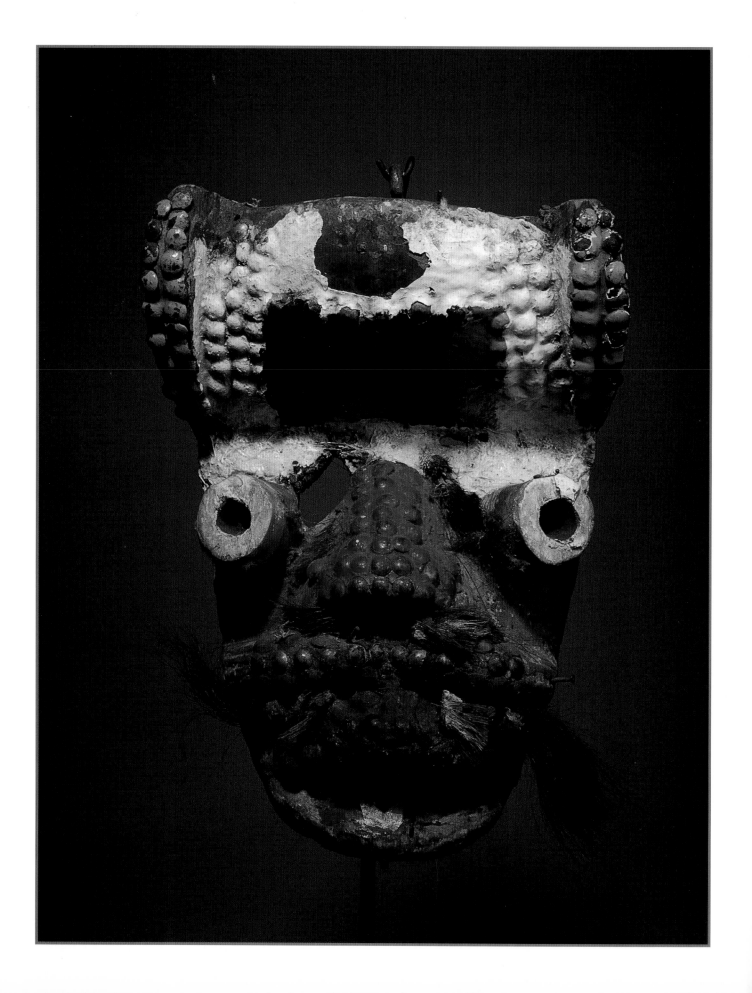

Opposite Page: Dan Guerre fetish mask.
Powerful mask used for healing, putting
curses on people.
Polychrome wood and tacks, 13".
Guere-Ouobe People
Liberia.
Courtesy of the Hemingway African
Gallery, New York.

Classic Dan mask used in Poro Society ritual. $500-600.
Wood, hemp, 9" h.
Dan People
Liberia or Ivory Coast

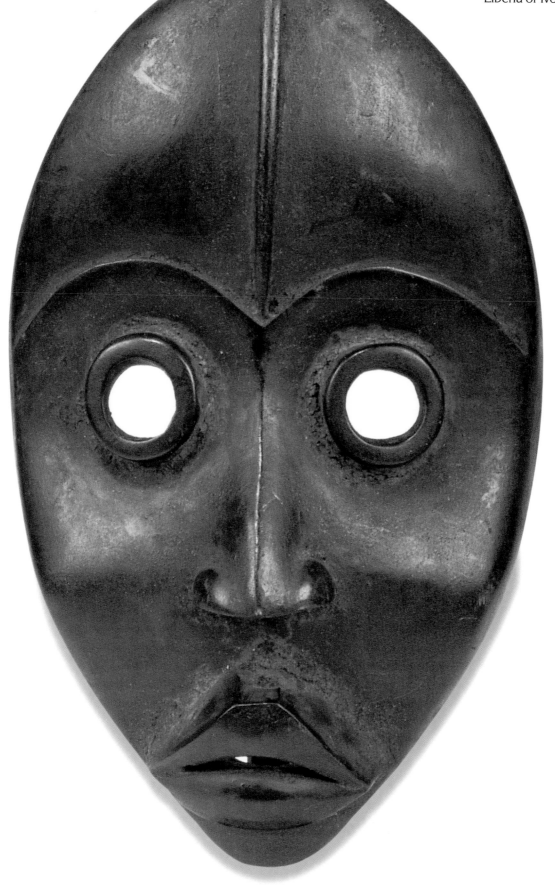

Classic Dan mask. $400-500.
Wood, 10" h
Dan People
Liberia or Ivory Coast

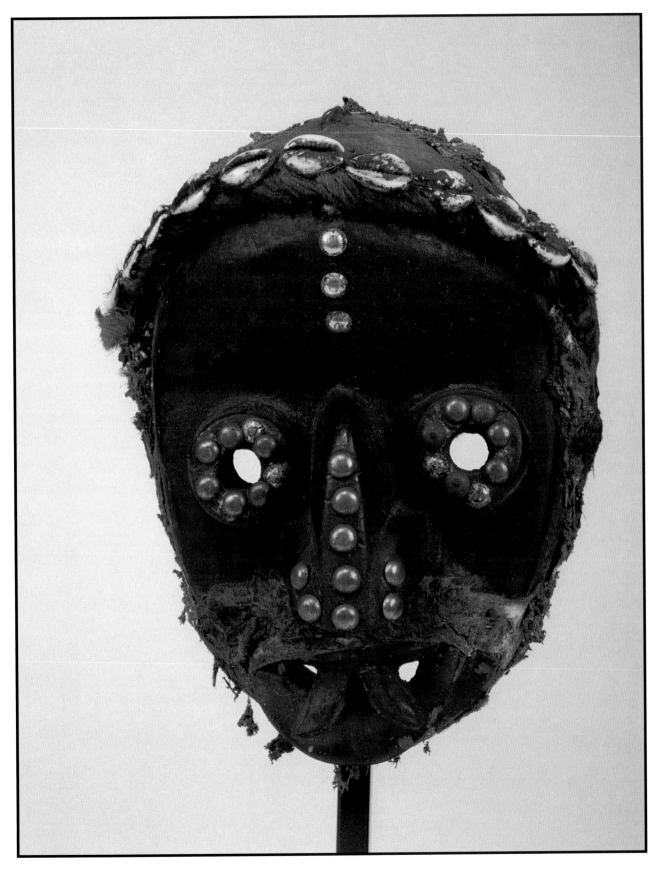

Fetish mask. $600-700.
Wood, cowries, metal, 9 1/2" h.
Dan People
Liberia or Ivory Coast

IVORY COAST

Ivory Coast is the home of the Baule, Bete, Senufo, Malinke, and Anyi peoples. Its population is nearing 15 million, over sixty percent of whom practice African religions. Another twenty-five percent are Muslim and over ten percent are Christian. It won its independence from France in 1970, having first received missionaries from France in 1637. As with most African countries, the history before European contact is still sketchy. The Baule and the Anyi invaded Ivory Coast in the eighteenth century.

Based on information from the University of Iowa, Art & Life in Africa project.

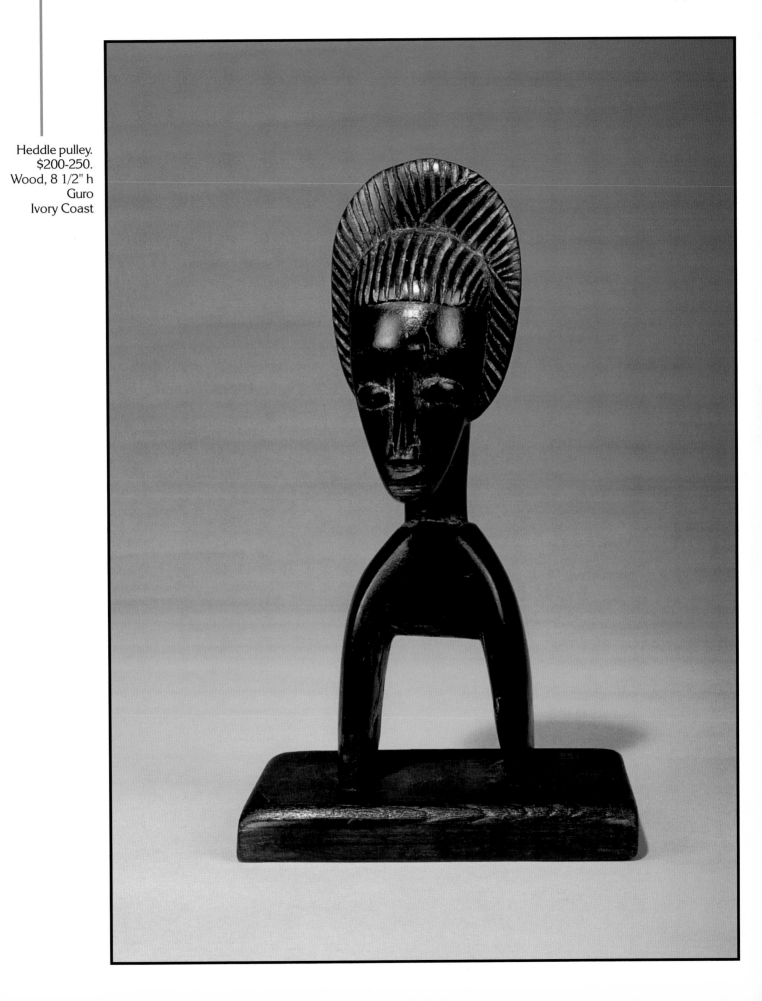

Heddle pulley.
$200-250.
Wood, 8 1/2" h
Guro
Ivory Coast

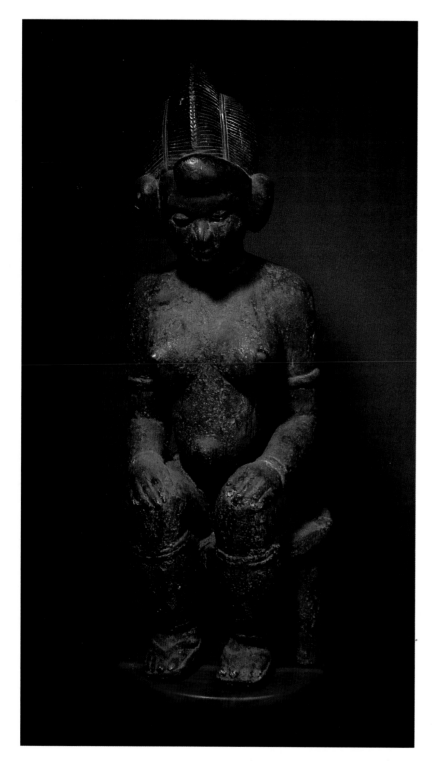

Seated female figure.
Wood, 32".
Baule People
Ivory Coast.
Courtesy of the Hemingway African Gallery, New York.

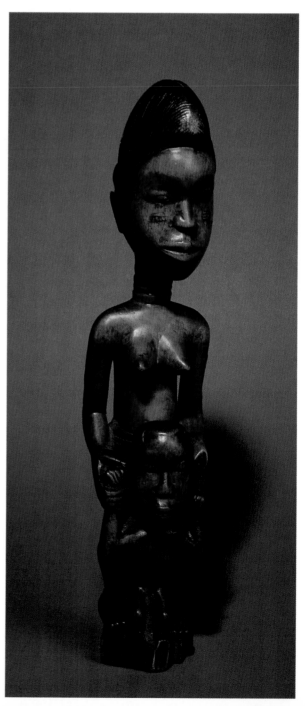

Sculpture of woman and child.
Wood, 15".
Baule People
Ivory Coast.
Courtesy of the Hemingway African Gallery, New York.

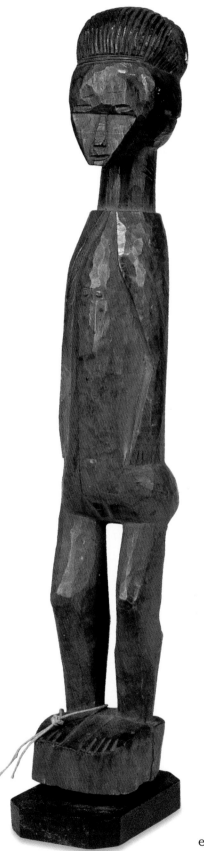

Female ancestor statue, in the old way of carving. $850-950. Wood, 19" h Baule People Ivory Coast

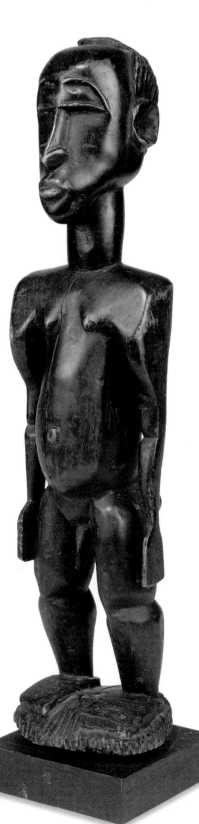

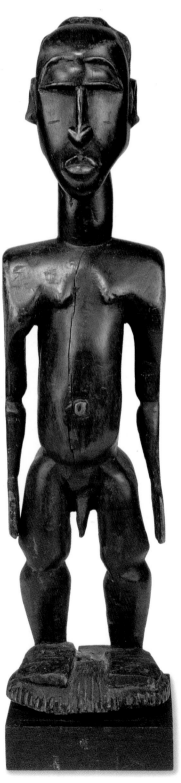

Male ancestor statue, from the early 20th century. $525-600. Wood, 21" h Baule People Ivory Coast

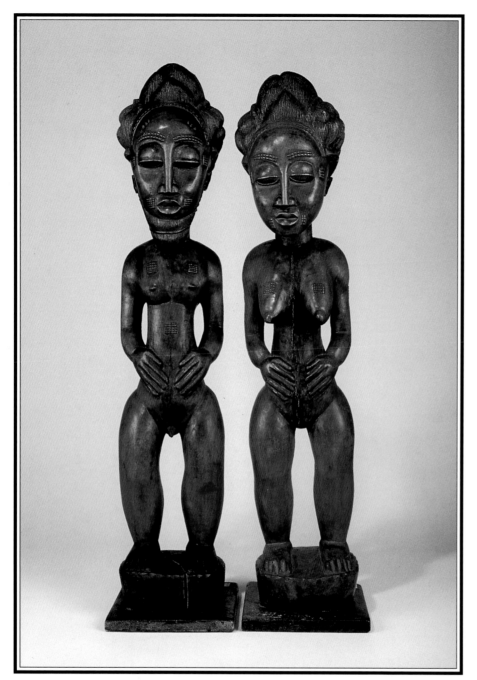

Two ancestor statues apparently by the same hand and likely made as a pair. Note the fine carving of the hair and features with scarification. These are examples of the classic Baule form. $900-1000 pair.
Left: Male ancestor statue.
Wood, 32" h
Right: Female ancestor statue
Wood, 32" h.
Baule People
Ivory Coast

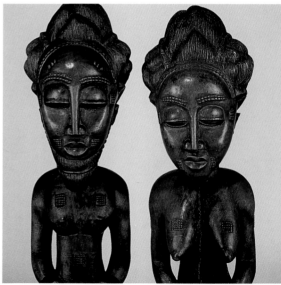

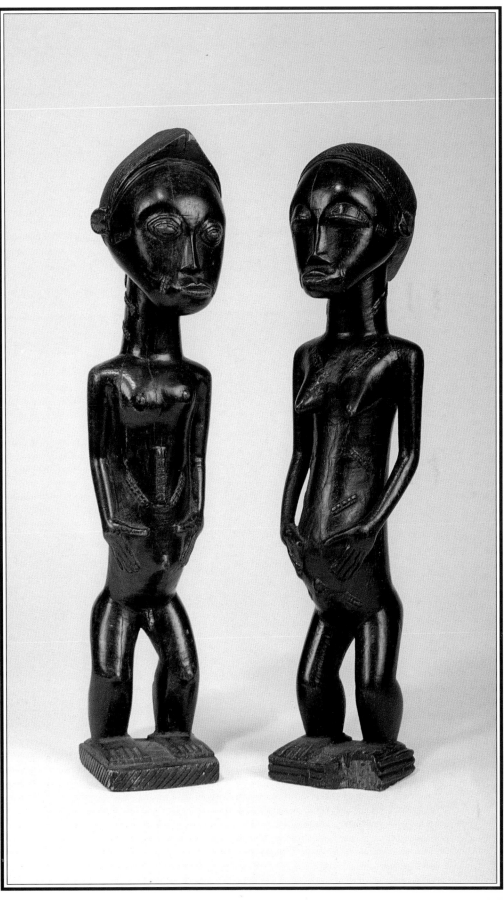

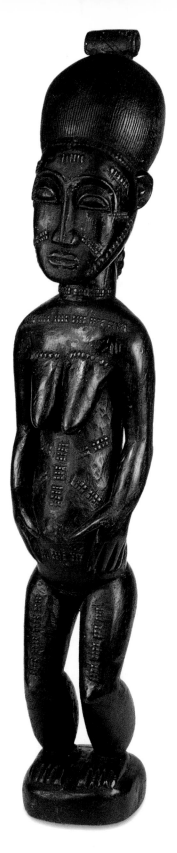

Female ancestor statue.
$825-900.
Wood, 40" h
Baule People
Ivory Coast

Another pair of ancestor statues
apparently from the hands of a single
carver. $700-800 pair.
Wood, 16" h
Baule People
Ivory Coast

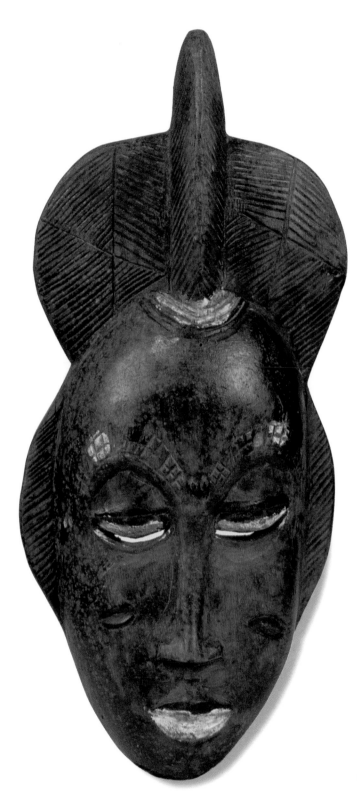

Mask with beautifully carved hairdo. The long nose, arched eyebrows, small mouth, and the hairdo divided into three sections are typical of Baule face masks (Segy, *ASS, p. 167*). $350-425.
Wood, 14" h
Baule People
Ivory Coast

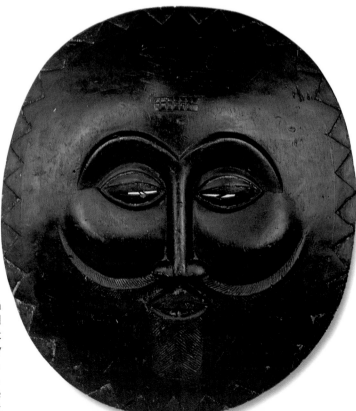

A beautifully carved, highly stylized moon mask, again showing the Baule treatment of the eyes, the long nose, and facial features including some scarification and a beard (?). It has similarities to the kplekple mask, but is much more finely rendered. $500-600.
Wood, black paint, 19" dia.
Baule People
Ivory Coast

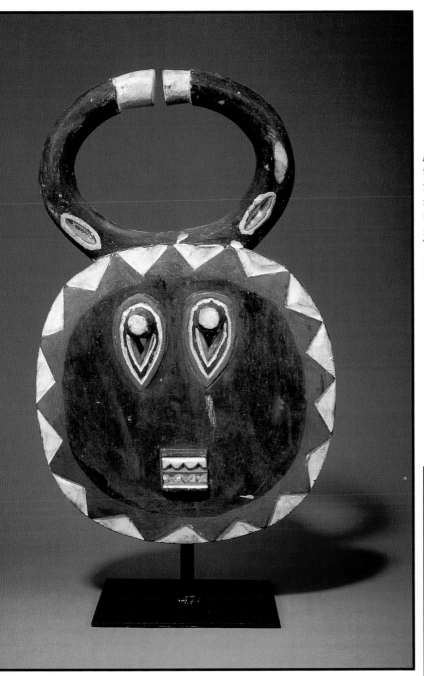

Kplekple mask, often referred to as the mask of the disobedient child, used for commemoration, funerals, and agricultural ceremonies at various seasons (Segy, *ASS, p. 169*). Its style is typical: round shape, inverted tear drop eyes, and small rectangular mouth. $450-525.
Wood, 18-1/2" dia.
Baule People
Ivory Coast

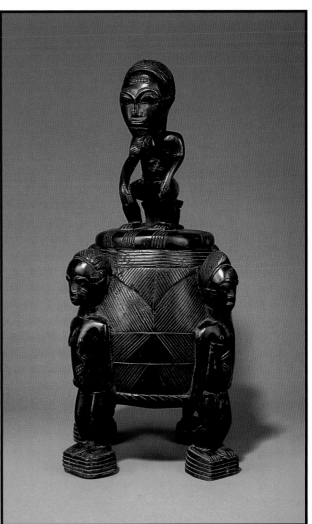

Medicine box. $800-900.
Wood, 19-1/2".
Baule People
Ivory Coast

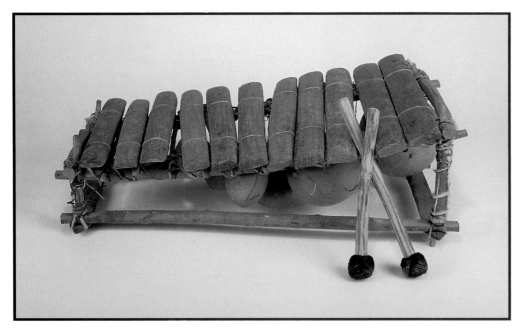

Balafone. This xylophone-like instrument has wood "keys" with gourds beneath to add to the resonance. $400-475.
Wood, gourds, and natural fibers, with wrapped rubber on tips of sticks, 25" long
Baule People
Ivory Coast

Ancestor mask surmounted by a second carved head. $500-575.
Wood, 17" h.
Guro People
Ivory Coast

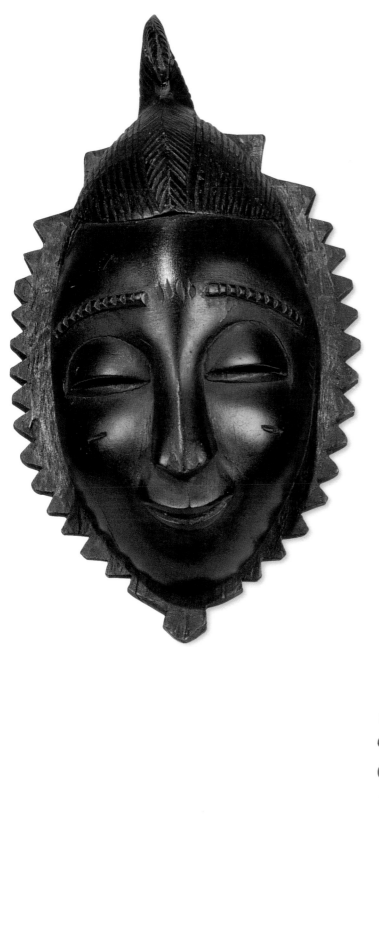

Mask with elaborately carved hairdo.
$500-575.
Wood, 12" h.
Guro People
Ivory Coast

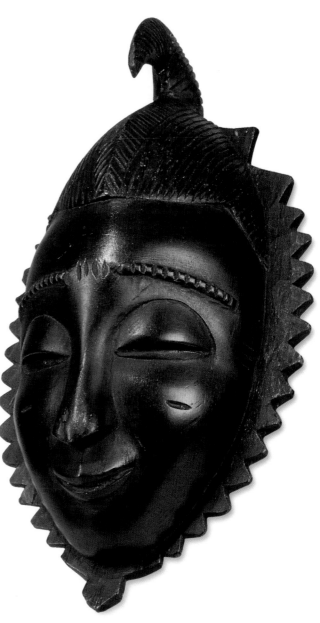

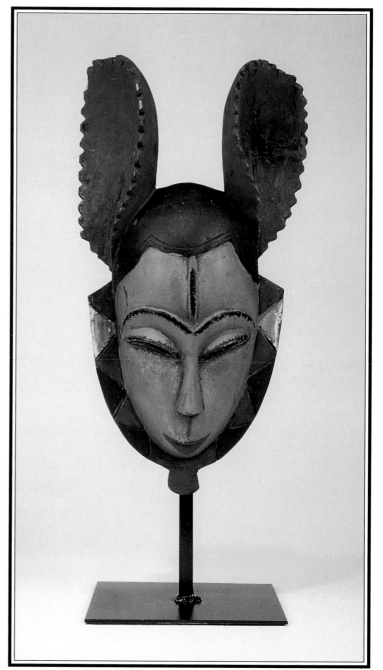

Mask with unusual rabbit-like ear
appendages. $600-700.
Polychrome wood, 15" h.
Guro People
Ivory Coast

Zamble mask combining features of the antelope and
crocodile. It is used in a dance featuring two dancers
representing male and female. Segy, *ASS, p. 177*).
$600-700.
Polychrome wood, 16" l
Guro People
Ivory Coast

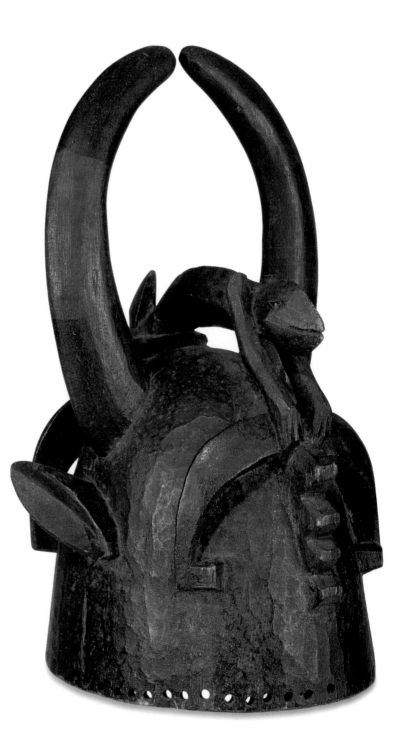

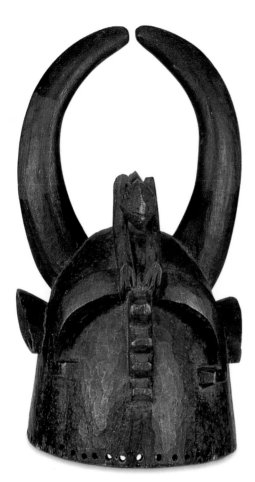

Headdress in the "bovine" form, surmounted
by a lizard. $800-900.
Wood, steel rod, 26" h
Senufo People
Ivory Coast

Kpelie masks represent ancestors, and are worn with full body costumes. This nicely carved example is surmounted by a bird figure, has leg like extensions at the chin, and four extensions beside the face, all typical of the form. $400-475 Wood, 16" h.
Senufo People
Ivory Coast

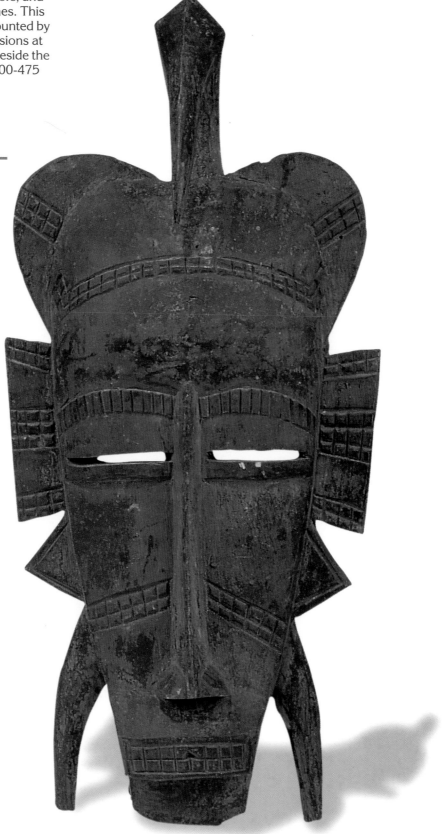

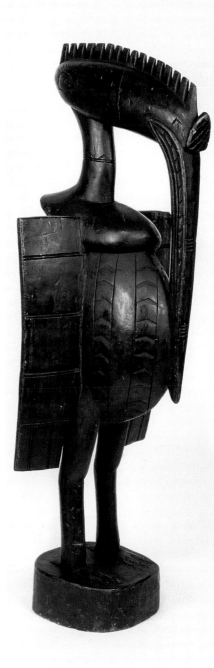

A rhythm pounder, called a *deble*. The figure stands on a round base. Reflecting the abstract style of other Senufo ancestor figures, this used to pound the earth, creating the rhythm for a dance (Segy, *ASS p. 171*). This example has a wonderful superstructure above the head with a crocodile figure in a square frame. $900-1000.
Wood, 54" h
Lo Society, Senufo People
Ivory Coast

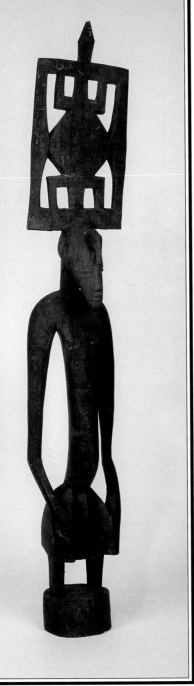

Porpianong, hornbill statue, a fertility symbol in the Lo Society. $600-700.
Wood, 43" h
Lo Society, Senufo People
Ivory Coast

Porpianong statue. $800-900.
Wood, 51" h.
Lo Society, Senufo People
Ivory Coast

GHANA

The major peoples making up this West African nation are the Asante, Fanti, Ewe, Dagomba, and Ga. Rich in natural resources, it was formed in 1957 from three British territories: Gold Coast, Asante, and Togoland. The population is nearing 18 million, on a land mass of 239,00 sq. km. Natural resources of gold, diamonds, manganese, fish and oil are the chief imports. The literacy rate is sixty percent, and the religion breaks down into thirty-eight percent African religion, thirty percent Muslim, twenty-four percent Christian, and eight percent other.

Encounter with the Europeans began in 1482 with the Portuguese and continued, over the centuries, to include Danes, Germans, and Dutch. Contact with the English started in 1553.

Based on information from the University of Iowa, Art & Life in Africa project.

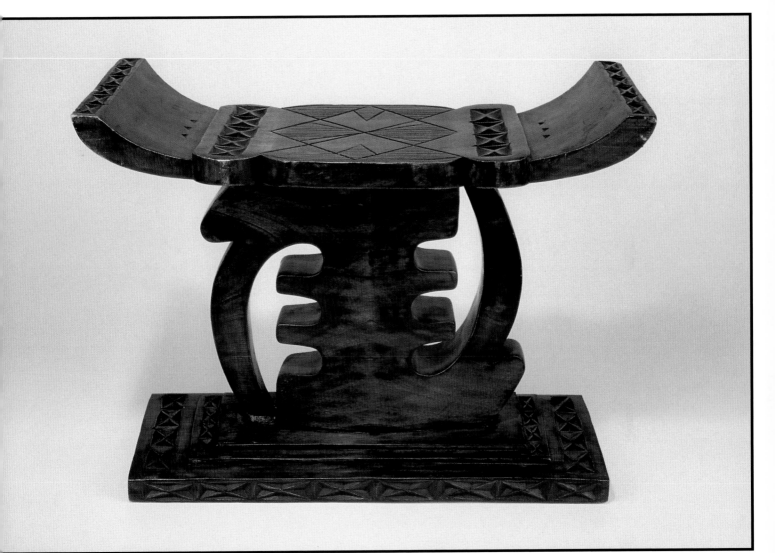

The Asante made these ceremonial stools in many variations. They shared in common the crescent shaped seat and the flat base, but differed in the carving of the pedestal. In this stool the symbol in the middle represents *gen nyane*. 20th century. $400-500.
Wood , 17" x 26"
Ghana

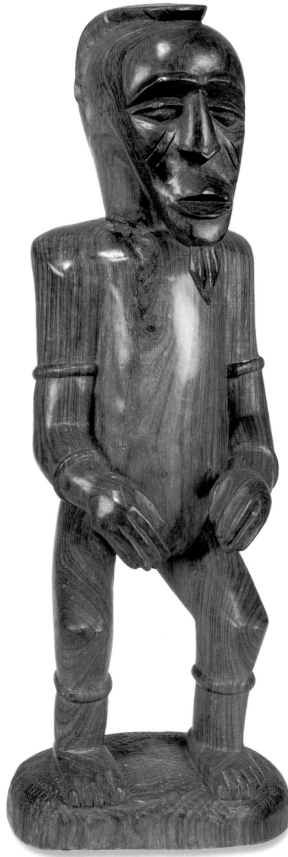

Nicely carved male statue with arm and leg jewelry,
sometimes referred to as *mmoatia* or "fairytale"
figures Segy, *ASS, p. 183*). $325-425.
Wood, 21" h
Asante People
Ghana

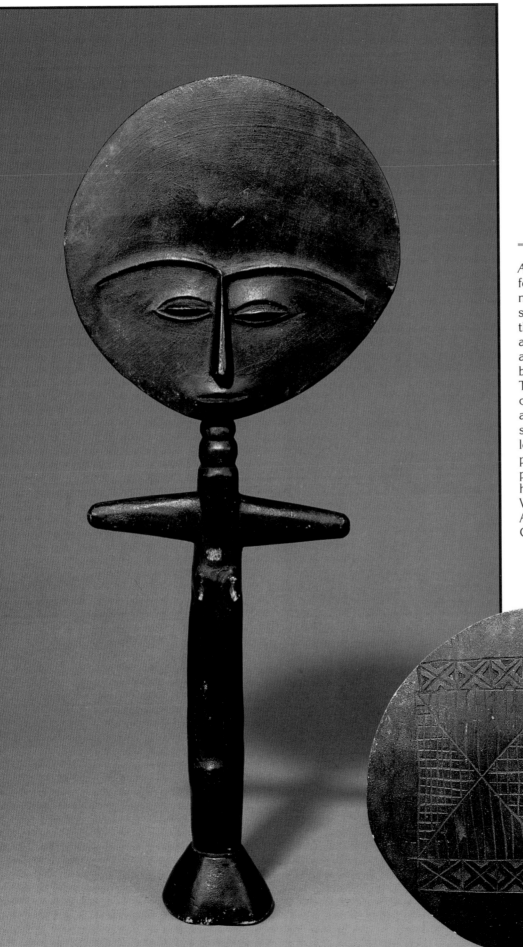

Akua'ba statue. This familiar form is, in some minds, synonymous with African sculpture. The statues were carried by women in the back of their waistclothes to aid in becoming pregnant, assure a good childbirth, or bestow beauty on the child that is born. The form with its round head, columnar body, and outstretched arms is common, though they sometimes are armless, have legs, or have a more naturalistic pose. There is a geometrical pattern carved on the back of the head. $300-350.
Wood, 15"
Asante People
Ghana

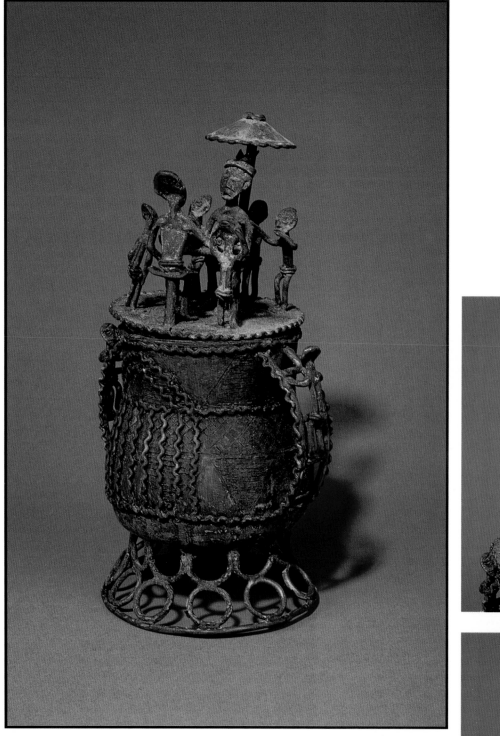

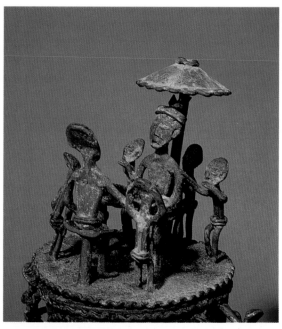

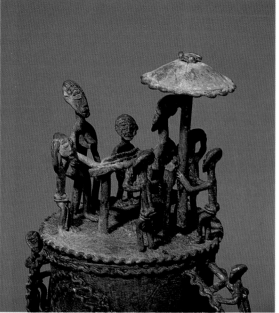

The original purpose of this *Kuduo* box was religious. Offerings were placed in it to gain protection and well being from the *ntoro*, the inherited male soul-substance, that resided there. The figures on the top are similar to gold weight figures and may represent a proverb or the royal family. $400-475.
Asante People
Ghana.

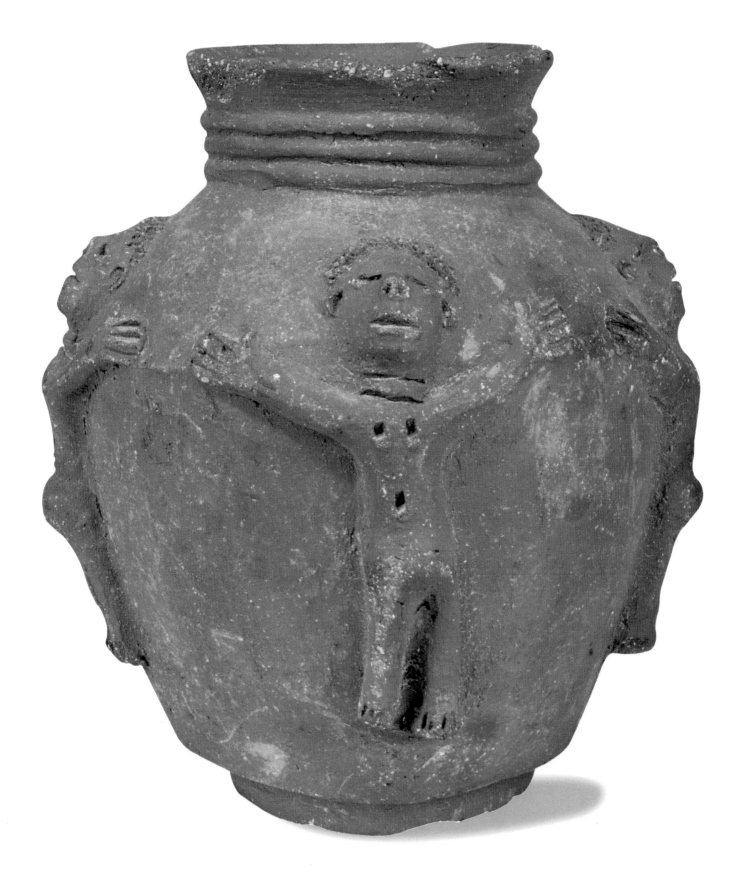

Burial pot with applied human figures. $400-475.
Terra-cotta, 11" h
Asante People
Ghana

SENEGAL

Today the population of Senegal is approaching 8 million, including the Wolof, Fulani, Serer, Toucoulor, and Diola peoples. It is ninety-two percent Muslim, twenty-five percent Christian, and six percent African religion. Strongly influenced by the Mandingo empires of the thirteenth and foureenth centuries, first contact with the Europeans came in the fifteenth century. The Portuguese, followed by the Dutch and the French, built ties with the area, culminating in French West Africa. In 1959, Senegal and French Soudan were combined to form the Federation of Mali. Conflicts led to the separation of the two entities into Senegal and Mali in 1960.

Based on information from the University of Iowa, Art & Life in Africa project.

Stringed instrument. $700-800.
Gourd, hide, wood, rope and metal tacks, 48".
Senegal.

MALI

The history of Mali can be traced back to the Ghana Empire, which ruled from about 700 to 1075. This was followed by the Malinke Empire, which came to power in the eleventh century and reached its height in the thirteenth century, when it controlled Timbuktu and Gao. As it declined the Songhai Empire rose to power out of Gao in the late fifteenth and sixteenth centuries. A Moroccan invasion brought an end to the Songhai reign in 1591 and the French military arrived in the 1880s. Following a brief merger with Senegal in 1959, to form the Federation of Mali, Mali gained total independence in 1960, becoming the Republic of Mali.

Today Mali has a population in excess of 9 million people. The major peoples are Bamana, Senufo, Dogon, Songhai, and Fulani. ninety percent are Muslim, nine percent practice African religions, and one percent are Christian.

Based on information from the University of Iowa, Art & Life in Africa project.

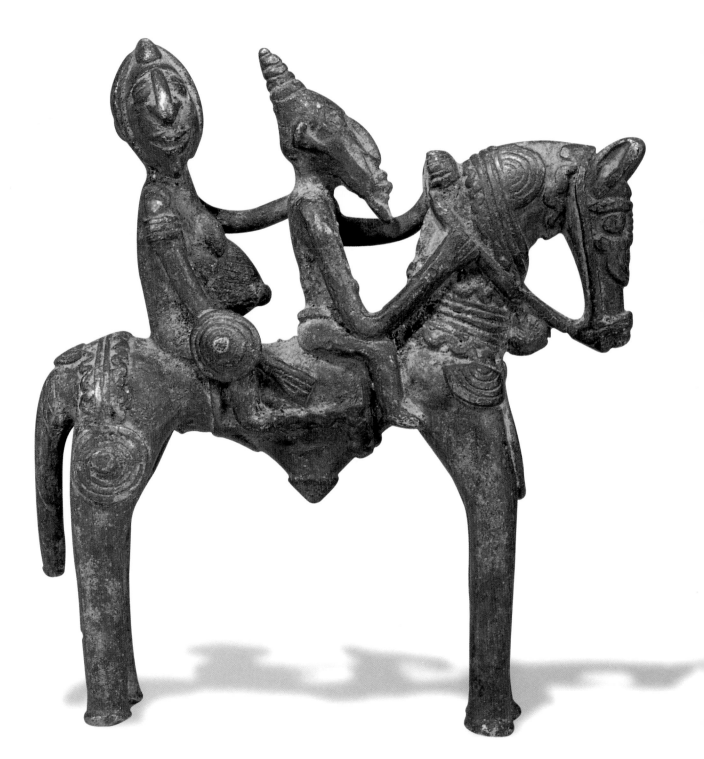

Nineteenth century bronze of a horseman with partner, who seems
to be pregnant. Nice detail in the casting helps indicate its age and
makes it more appealing. $650-750.
Bronze, 6" l x 7" h
Dogon People
Mali

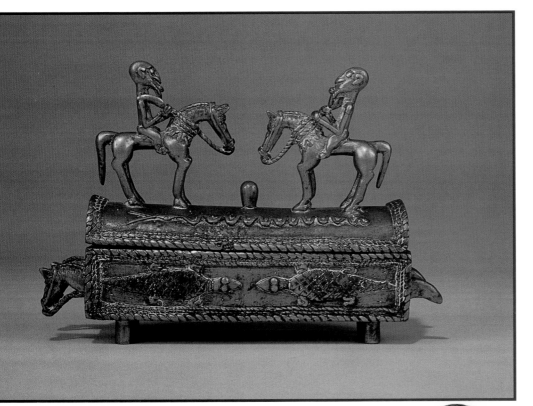

Nineteenth century jewelry box surmounted by two mounted horsemen and decorated with crocodile figures, with a horses head at the front and tail at the rear. $825-925.
Cast brass, 10-1/2" l.
Dogon People
Mali

Rider with spear. $425-500.
Bronze, 7" h x 8"
Dogon People
Mali

Similar themes to the brass jewelry box, though having only one horse and rider. This wooden version also has a removable lid. $1500-1600.
Wood, with top
Dogon people
Mali

Three-tier feeding pot, with chambers supported by figures of a horse and various people, and surmounted by a rider and horse. The detail of the carving is exquisite. $400-475.
Wood, 26" h
Dogon People
Mali

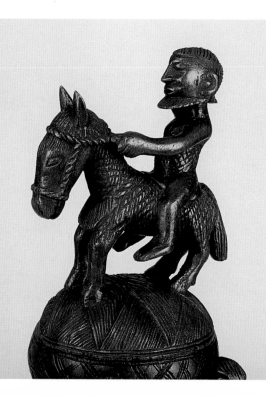

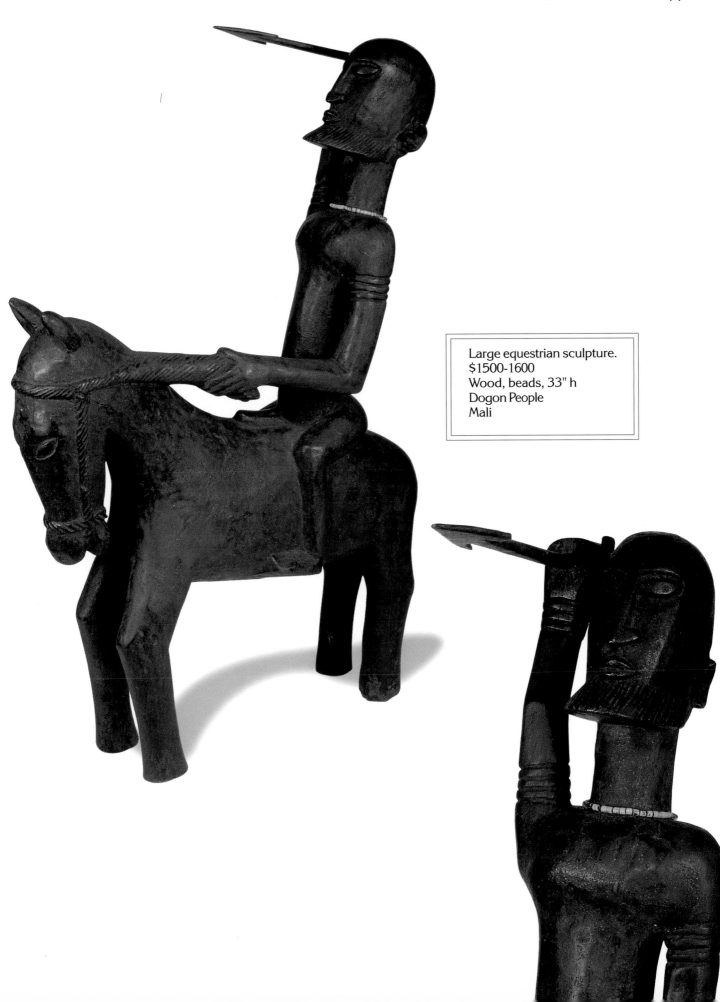

Large equestrian sculpture.
$1500-1600
Wood, beads, 33" h
Dogon People
Mali

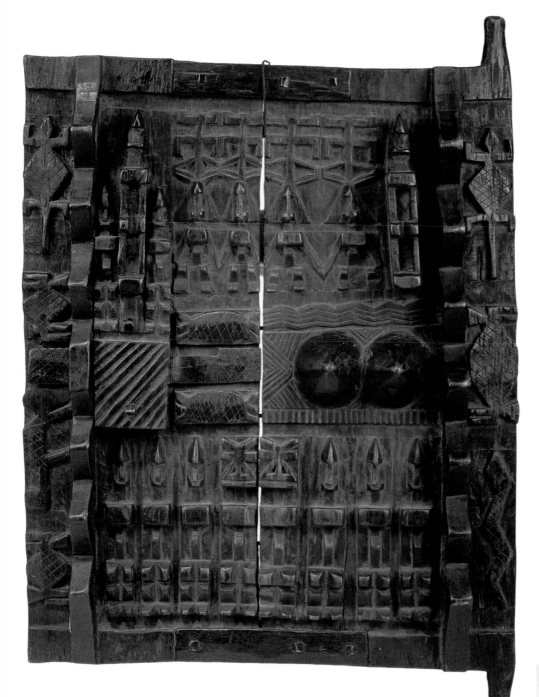

Granary door, with detail of carved figures wearing masks. $425-500.
Wood, 27" x 15"
Dogon People
Mali

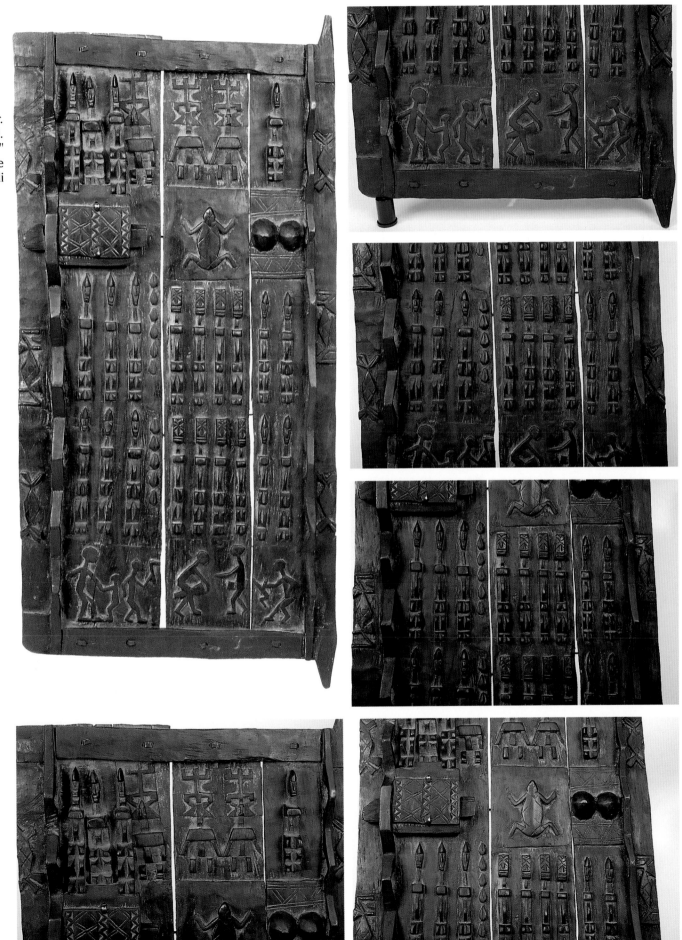

Granary Door.
$525-600.
Wood, 21" x 43"
Dogon People
Mali

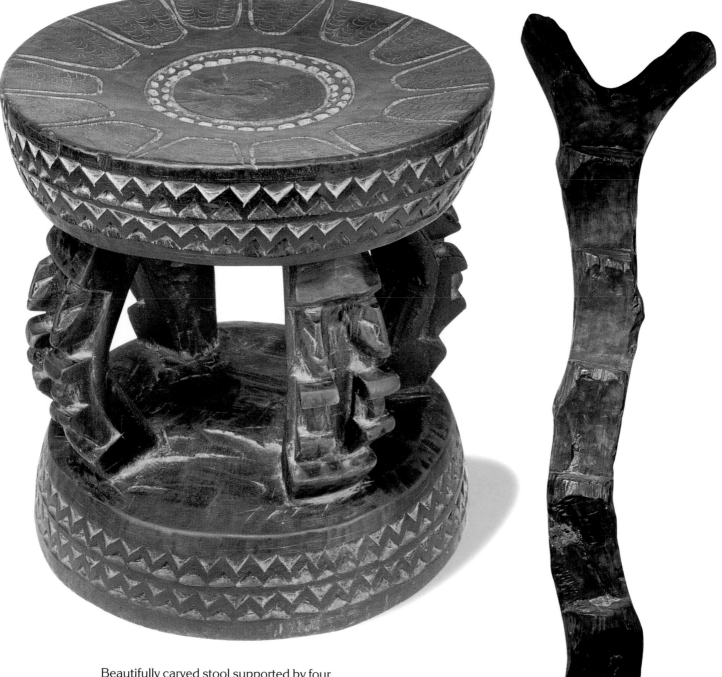

Beautifully carved stool supported by four
figures. $375-450.
Wood, 14"
Dogon People
Mali

Ladder carved from a tree.
$1700-1800.
Wood, 68"
Dogon People
Mali

rst family sculpture
representing the
beginning of the
Dogon people.
$350-425.
Wood, 17" h.
Dogon People
Mali

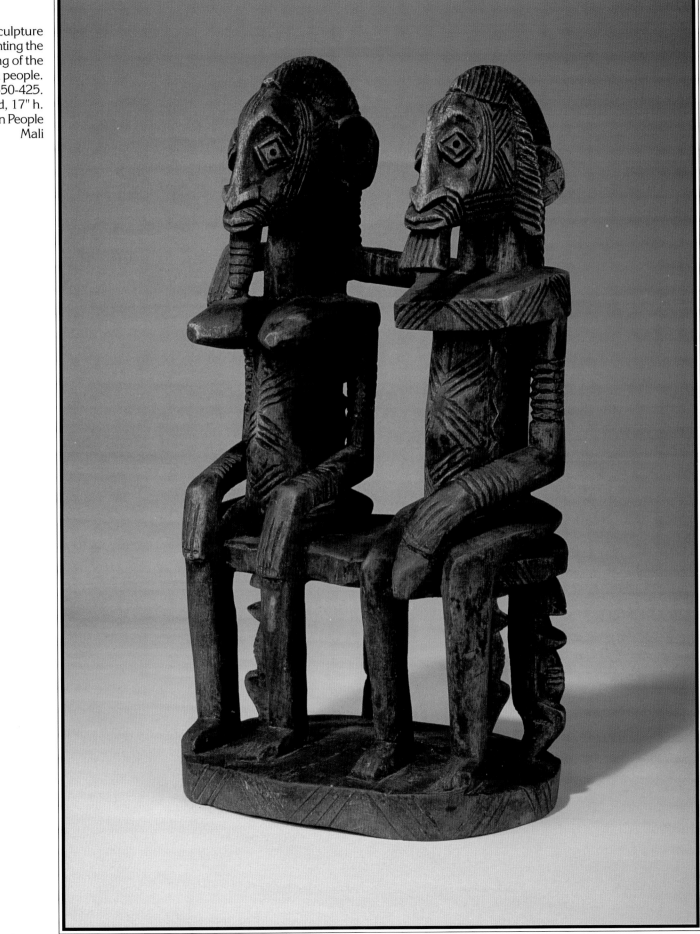

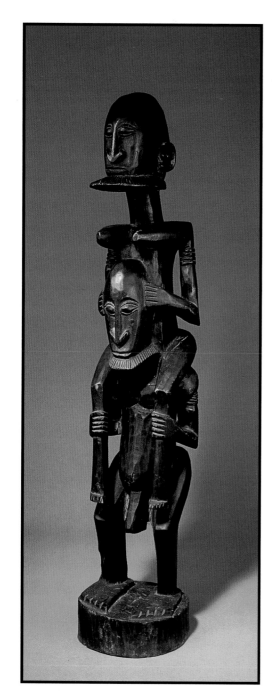

Piggyback figures, male carrying female.
$300-350.
Wood, 37".
Dogon People
Mali

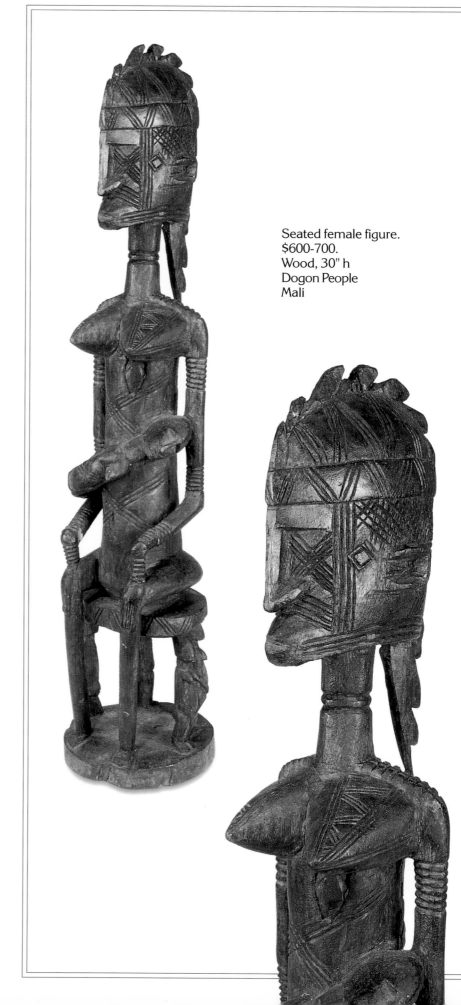

Seated female figure.
$600-700.
Wood, 30" h
Dogon People
Mali

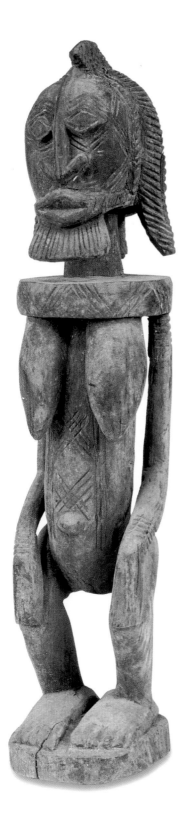

Statue of a woman. $550-625.
Wood, 22" h.
Dogon People
Mali

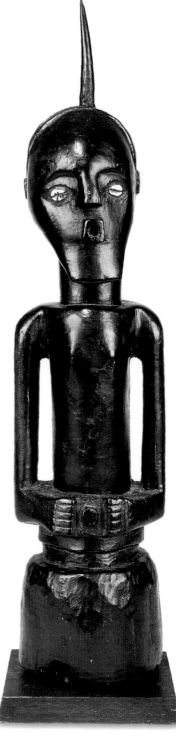

Fetish. $725-825.
Wood, 22 1/2 h
Dogon People
Mali

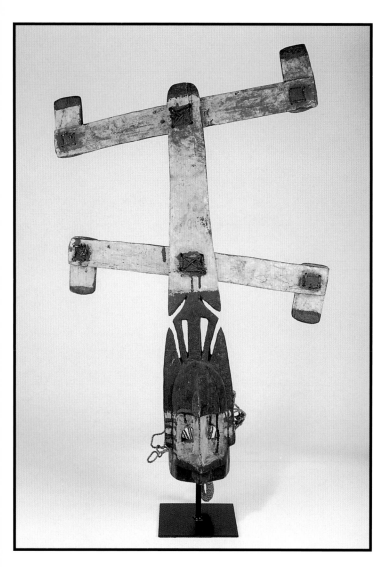

Mask with super structure. $750-850.
Wood, twine, 35" h.
Dogon People
Mali

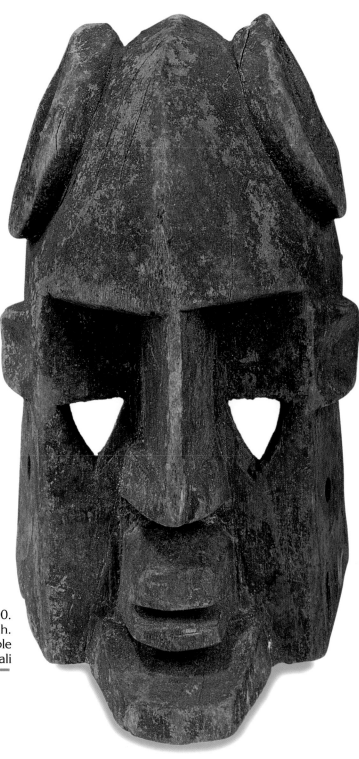

Mask. $900-1000.
Wood, 13" h.
Dogon People
Mali

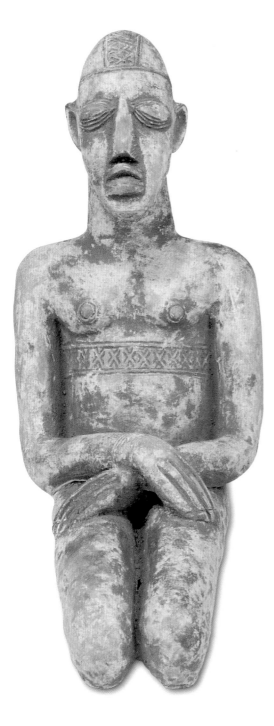

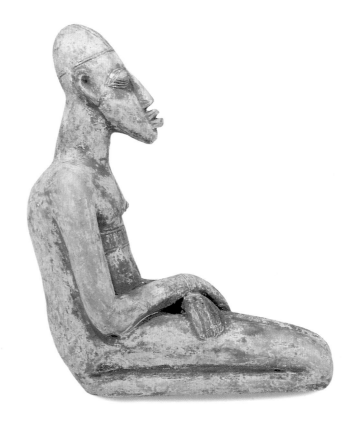

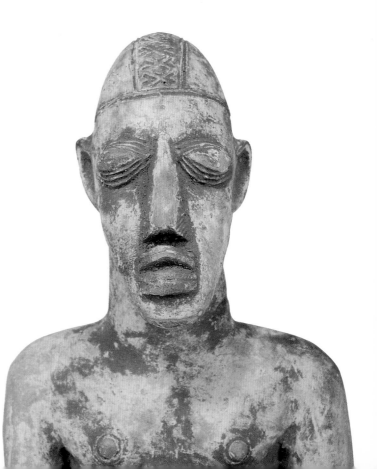

This beautiful clay nineteenth century seated figure is reminiscent of Egyptian forms. Its creator was Djenne, a people that is extinct. $1600-1700.
Terra-cotta, 12" h
Djenne People
Mali

Djenne horse and rider. $1800-1900.
Terra-cotta, 15" h
Djenne People
Mali

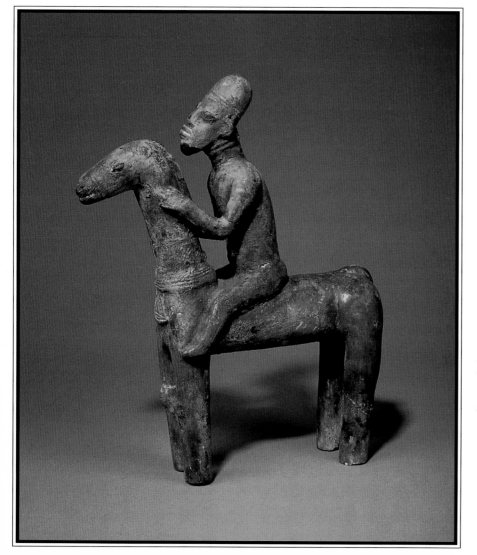

Late nineteenth century pottery horseman. The
condition and form of this older piece make it
truly spectacular. $3600-3800.
Terra-cotta, 13-1/2" x 10-1/2"
Djenne People
Mali.

Ancestor figure. $625-700.
Wood, 26" h
Bambara People
Mali

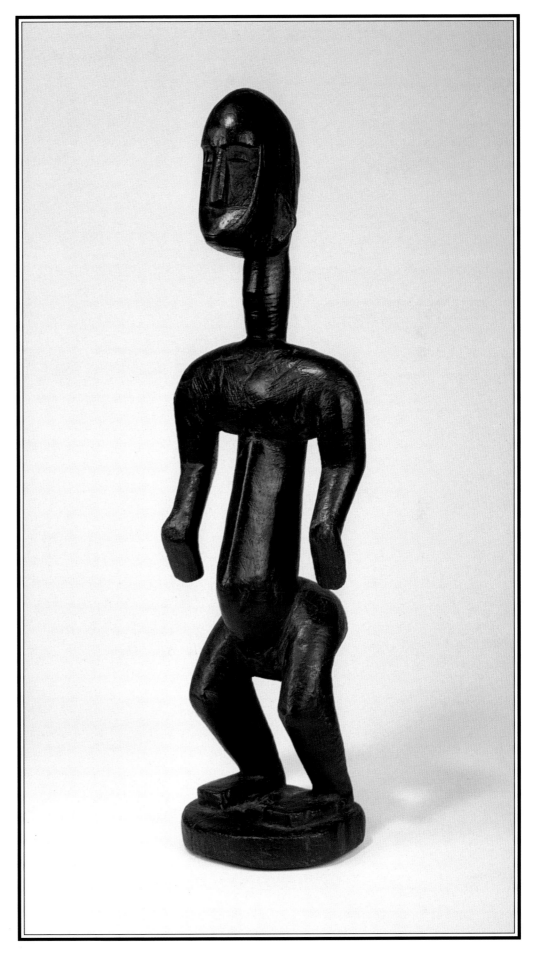

Old Chi Wara. $350-425.
Wood, with encrustation, 30"
Bambara People
Mali

Chi Wara. $450-525.
Wood, cowries, burlap, beads, 28" long
Bambara People
Mali

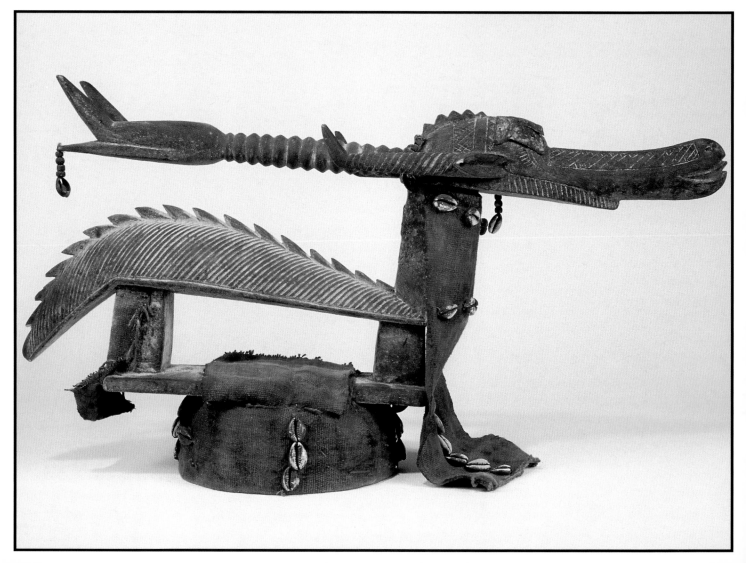

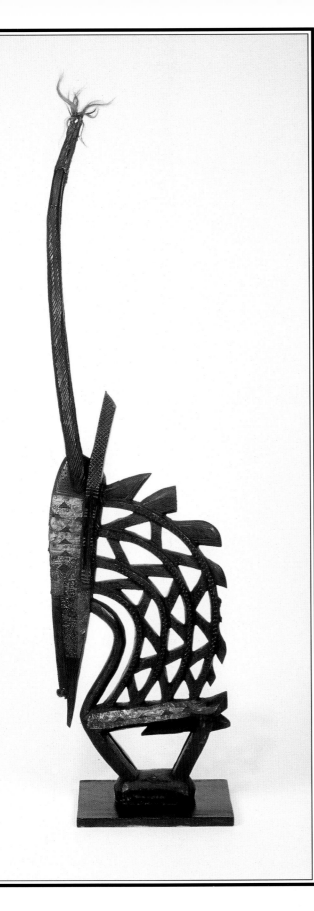

Male Chi Wara. $500-525.
Wood, metal, cotton, nails, 50" h
Bambara People
Mali

Female Chi Wara.
$425-500.
Wood, metal, 21" h
Bambara People
Mali

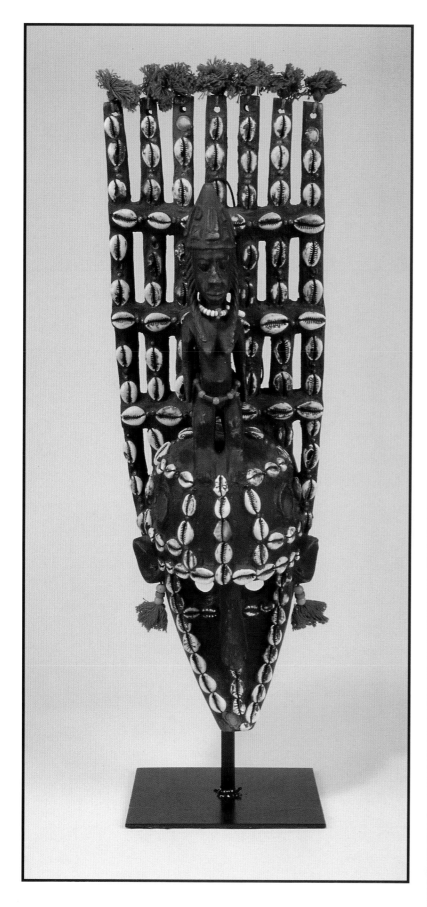

N'Toma mask. $400-500.
Wood, cowries, 24" h.
Bambara People
Mali

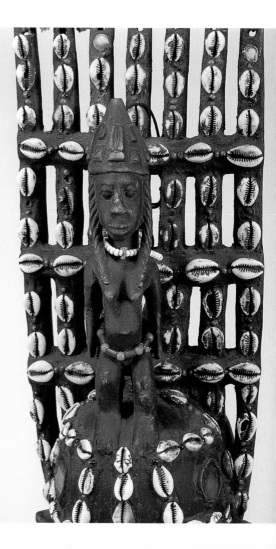

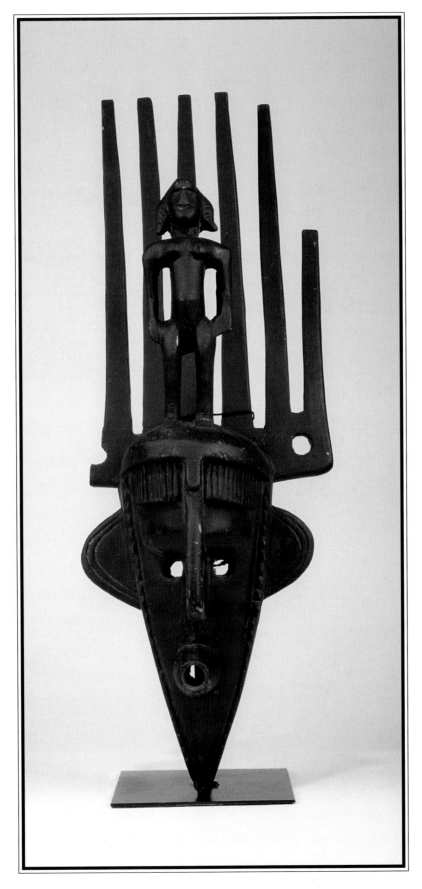

N'Toma mask. $350-450
Wood, 28" h
Bambara People
Mali

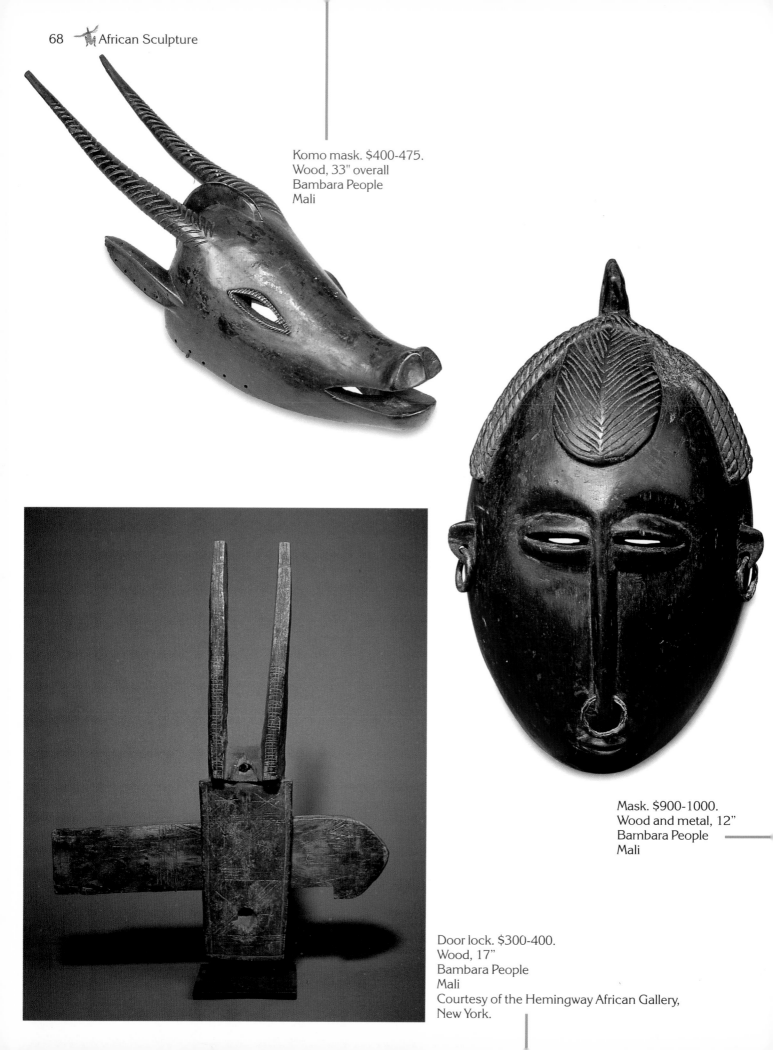

Komo mask. $400-475.
Wood, 33" overall
Bambara People
Mali

Mask. $900-1000.
Wood and metal, 12"
Bambara People
Mali

Door lock. $300-400.
Wood, 17"
Bambara People
Mali
Courtesy of the Hemingway African Gallery,
New York.

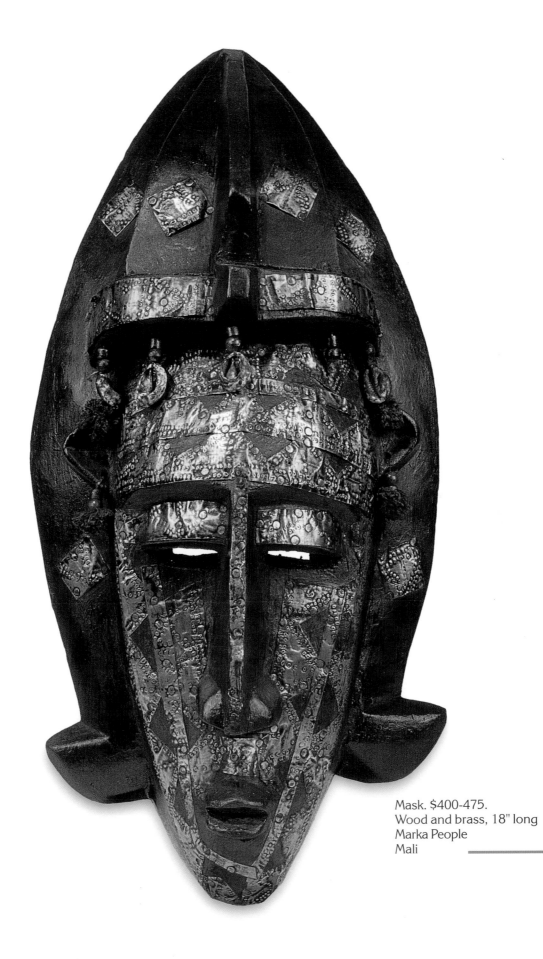

Mask. $400-475.
Wood and brass, 18" long
Marka People
Mali

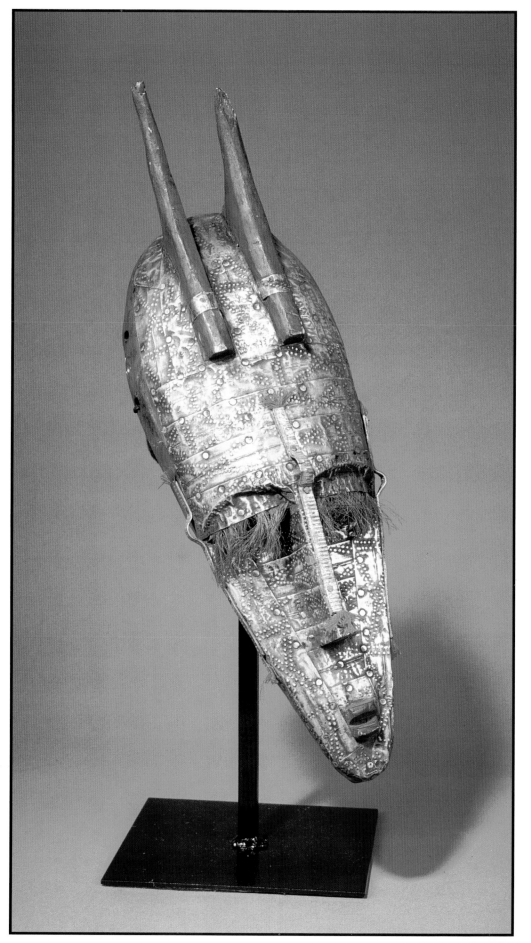

Mask. $375-450.
Wood, brass, nails and fiber, 19"
Marka People
Mali

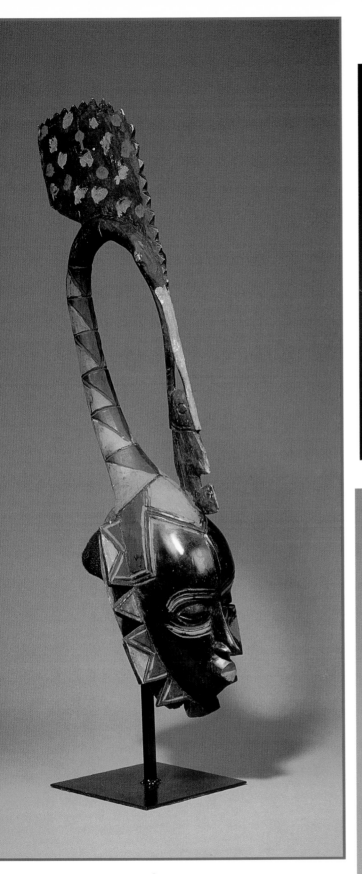

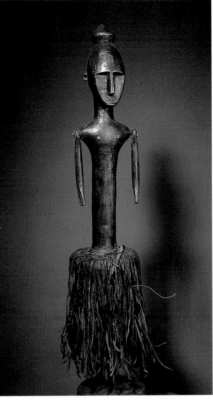

Bronze marionette carried in processions. Jointed arms. Bronze and fiber, 28" from bottom of skirt
Mali
Courtesy of the Hemingway African Gallery, New York.

Above and Right: A recently carved mask from Ivory Coast. $475-500.
Polychrome wood, 31"
Guru People
Ivory Coast

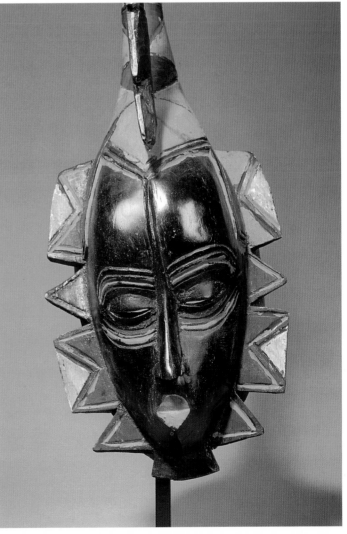

BURKINA FASO

Burkina Faso became independent from France in 1960 following sixty-three years of colonialism. According to the University of Iowa's Art & Life in Africa Project, they were years of intentional neglect and underdevelopment. By not building an infrastructure or industry, the French sought to force people to go to the Ivory Coast to find work on French plantations or factories at meager wages. Since independence, the international community has made successful efforts to build the nation's economy.

Prior to the French colonial period Burkina Faso was dominated by the Mossi, who, with their mounted armies, had had a strong military since the 1500s. Their period of power was marked by a relative peacefulness, and the development of crafts and trade, including participation in the slave trade.

Today Burkina Faso has a population of nearly 11 million and covers 274,500 square kilometers, making it the second most densely populated country in Africa. The major peoples are the Mossi, Gurunsi, Senufo, Lobi, Bobo, and Fulani. fifty percent of the population is Muslim, forty percent practice African religions, and five percent are Christian.

Based on information from the University of Iowa, Art & Life in Africa project.

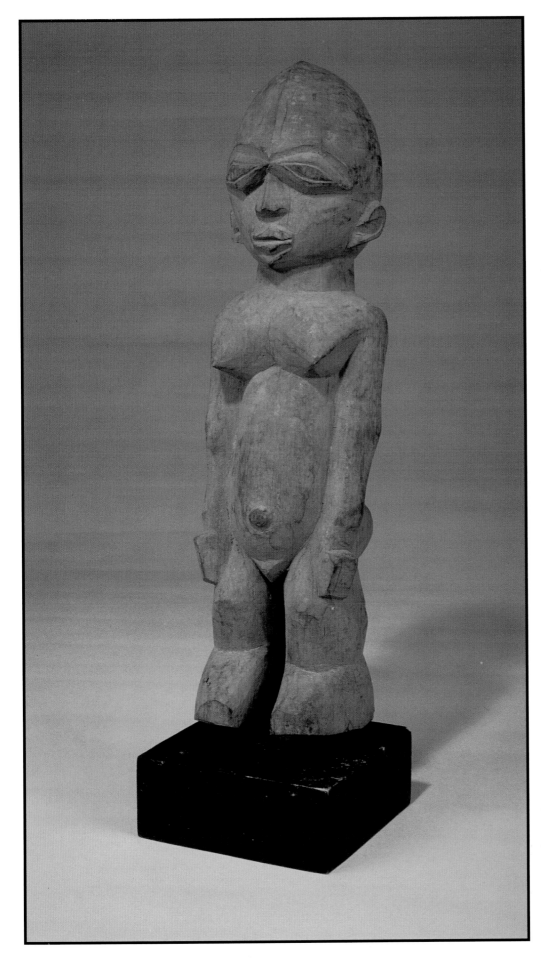

Statue in the typical bulbous
form of Lobi sculpture. $650-
750.
Wood, 17" h.
Lobi People
Burkina Faso or Ivory Coast

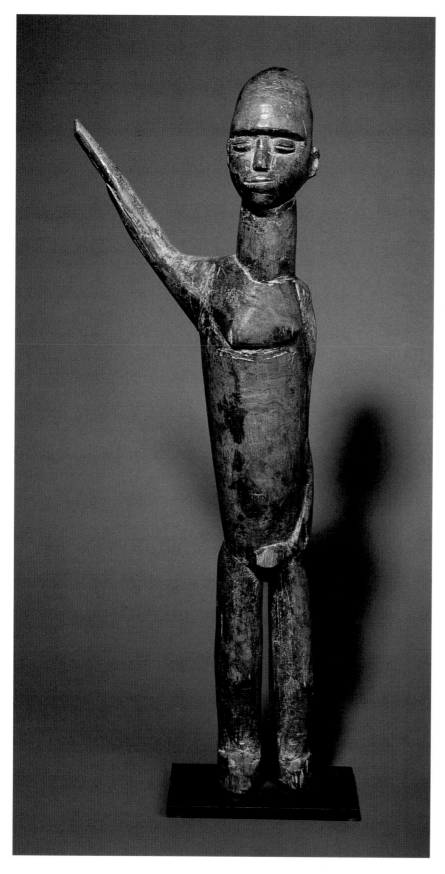

Statue in an elongated form with an out-stretched arm. The carving, as with most Lobi sculpture does not show great sophistication.
Wood, 19"
Lobi People
Burkina Faso or Ivory Coast
Courtesy of the Hemingway African Gallery, New York.

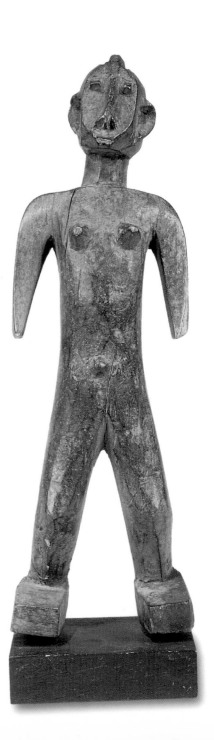

Male statue. $1925-2100.
Wood, 23" h
Lobi People
Burkina Faso

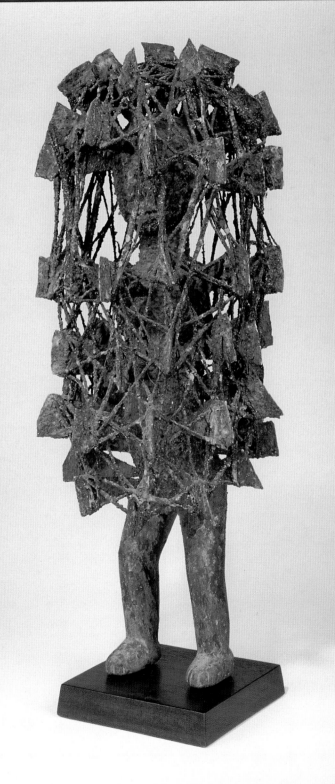

A highly unusual fetish figure.
$3000-3400.
Wood, metal, string, 21" h
Mossi People
Burkina Faso

Antelope mask from the Bobo-Dioulasso region. The mask is worn on top of the head, so that the wearer's face is covered. Subtly painted with geometrical designs. $425-500.
Polychrome wood, 26" h
Bobo-Fing or Bobo-Dioula People
Burkina Faso

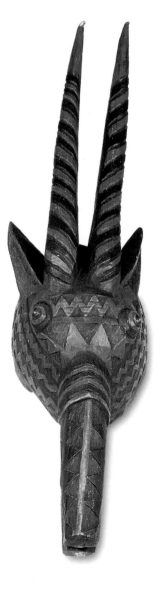

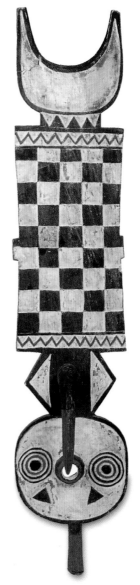

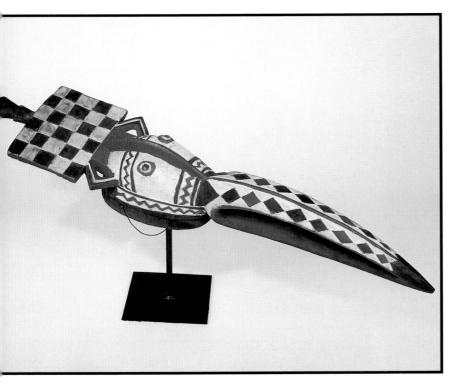

Bird mask from the Koudougou region, featuring typical polychrome abstract decorations, This has a long beak and is surmounted by a "checker board" panel. $350-450.
Polychrome wood, 36" h
Bobo People
Burkina, Faso

Among the best known Bwa masks are these plank masks used in agricultural rituals. Sometimes reaching eight or more feet in height, the are worn by costumed dancers. $425-500.
Polychrome wood, 54" tall
Bwa People
Burkina Faso

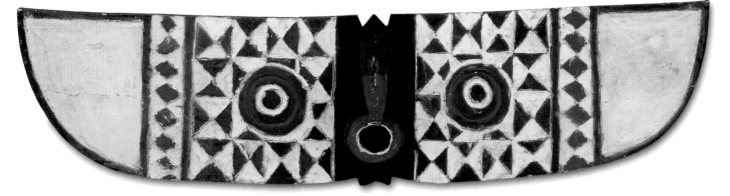

Butterfly mask, also known as a Hawk mask. $400-475
Polychrome wood, 36" x 9"
Bwa People
Burkina Faso

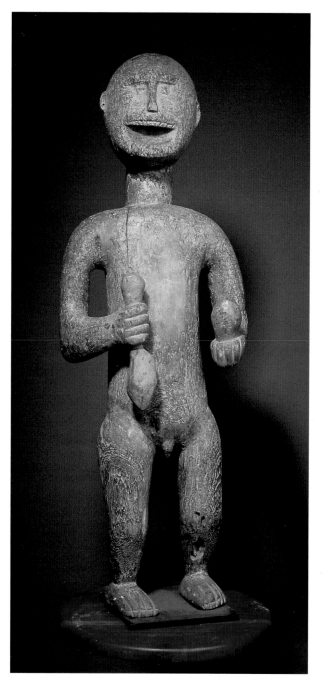

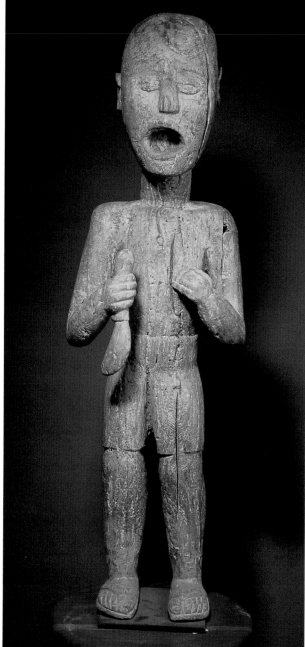

Statue,
Bwa People
Wood, 30"
Burkina Faso
Courtesy of the Hemingway African
Gallery, New York.

Statue.
Wood, 34".
Bwa People
Burkina Faso
Courtesy of the Hemingway African
Gallery, New York.

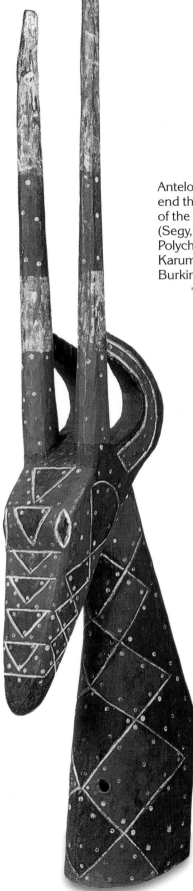

Antelope headdress. When mourning was coming to an
end this headdress was worn to chase away the spirit
of the deceased, who might seek to harm the living
(Segy, *ASS, p. 180*). $600-650.
Polychrome wood, 58" h
Karumba
Burkina Faso

BENIN

Benin grew out of several entities, including the Fon Kingdom of Dahomey, which came into being in the 1600s. It was actively involved in the slave trade, and had several trading outposts on the coast, notably Porto Nuovo and Ouidah. Trading also took place in the north with other Africans and Arabs. In the mid-1800s slavery began to diminish and social and political unrest began to grow. In 1892, the King of Dahomey was defeated and the French came to power. The colonization of Benin lasted until 1960.

Today Benin has a population of 5.5 million, with strong representation from the Fon, Adja, Yoruba, and Bariba peoples. Seventy percent of the people practice African religions, fifteen percent Muslim, and fifteen percent Christian.

Based on information from the University of Iowa, Art & Life in Africa project.

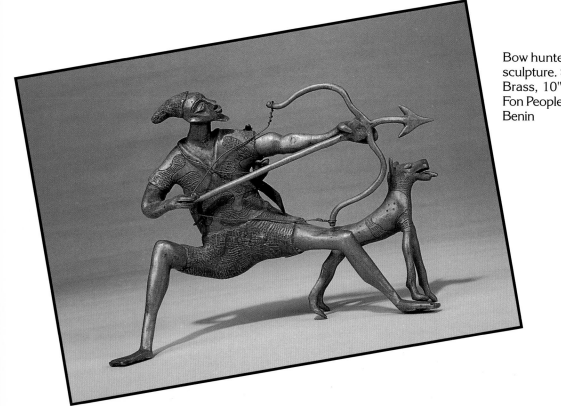

Bow hunter with dog, 20th century sculpture. $400-450.
Brass, 10" w x 8" h
Fon People
Benin

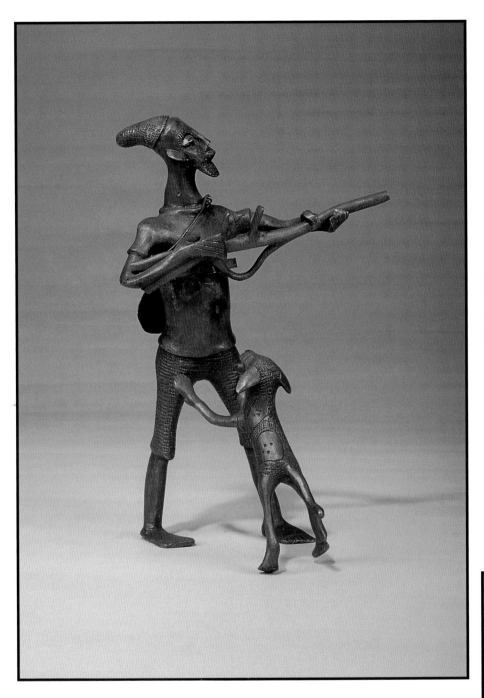

Hunter with dog, 20th century
sculpture. $300-350.
Brass, 10" h
Fon People
Benin

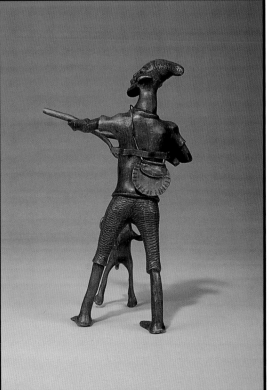

NIGERIA

Federal Republic of Nigeria is home to four major tribal groups: the Yoruba, the Igbo, the Hausa, and the Fulfulde. With a population in excess of 110 million, they have a strong Muslim and Christian tradition, accounting for fifty percent and forty percent, respectively, with African religion making up the other ten percent.

Nigeria's history is long. The Nok culture dates to more than two thousand years ago, and produced ironwork and wonderful terra cotta that has been unearthed in this century. One piece is shown here. Nigeria was situated on the trade routes between the northern Berbers and the forest people of the south. Slaves, ivory, and other products were among the traded goods. The Yoruba Kingdom was established in the fifteenth century and reached its pinnacle in the seventeenth through nineteenth centuries. Trade relations with European nations included slaves, replaced by palm oil and timber when slavery ended. Today Nigeria is a major exporter of oil and minerals.

British colonization ended in 1960. A period of political unrest ensued, including the Biafran civil war of the late 1960s. After several military governments, elections were held in 1999 leading to the election of Olusegun Obasanjo.

Based on information from the University of Iowa, Art & Life in Africa project.

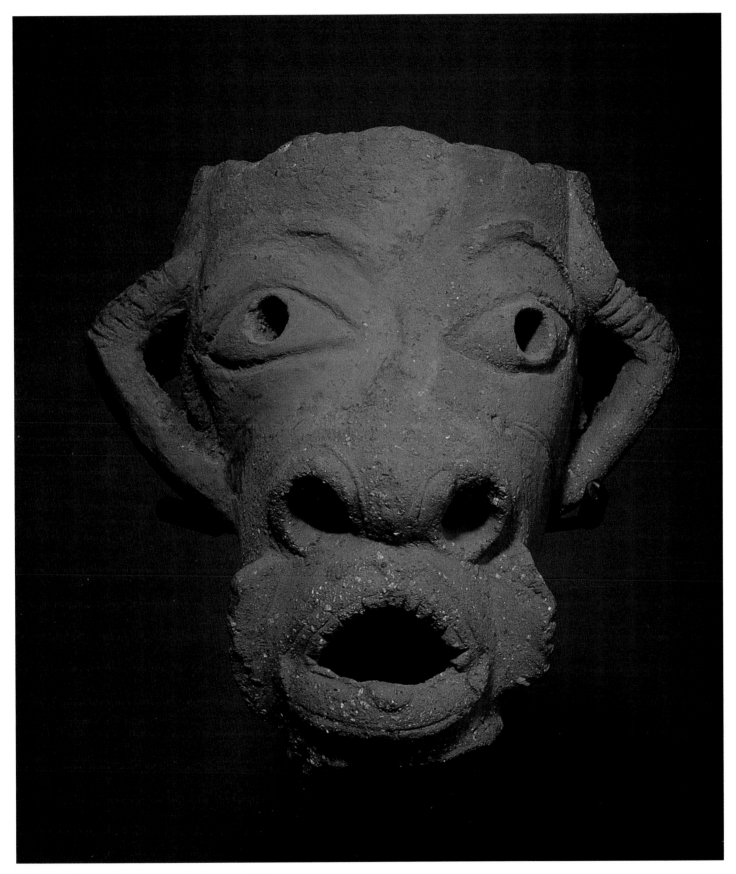

Ancient funeral piece, from Nok, circa 300 BC.
Terra-cotta, 12".
Nigeria.
Courtesy of the Hemingway African Gallery, New York.

Bronzes

The Benin Kingdom of Nigeria established a long and creative period of casting bronze figures. Using the lost wax technique, they produced stunning works that showed not only artistic sophistication but technological expertise. The west became aware of the Benin bronzes in the late 19th century, finding them among the ruins of the old city. Most of these ancient works of art are in museums in Nigeria and around the world.

In twentieth century Nigeria the art of bronze sculpture continues as will be seen by the examples that follow. Most comes out of the territory of the old Benin Kingdom.

Oba, or king, beautifully cast in bronze. 20th century. (Yoruba). $550-625.
Bronze, 15" h
Yoruba People
Nigeria

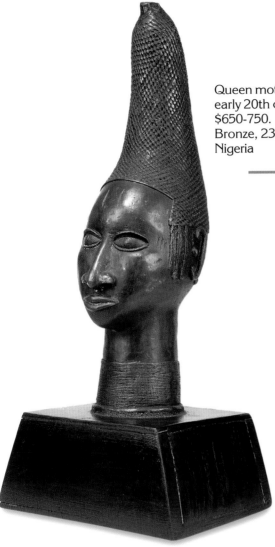

Queen mother, a commemorative piece from the
early 20th century, reflecting a much earlier form.
$650-750.
Bronze, 23" h.
Nigeria

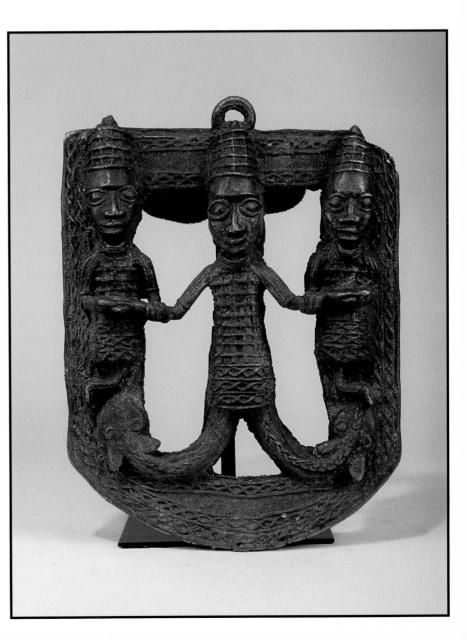

Wall plaque repeating a theme of old Benin
plaques. The middle figure is an *Oba*, with a
servant on each side. 20th century. $550-625.
Bronze, 15"
Nigeria

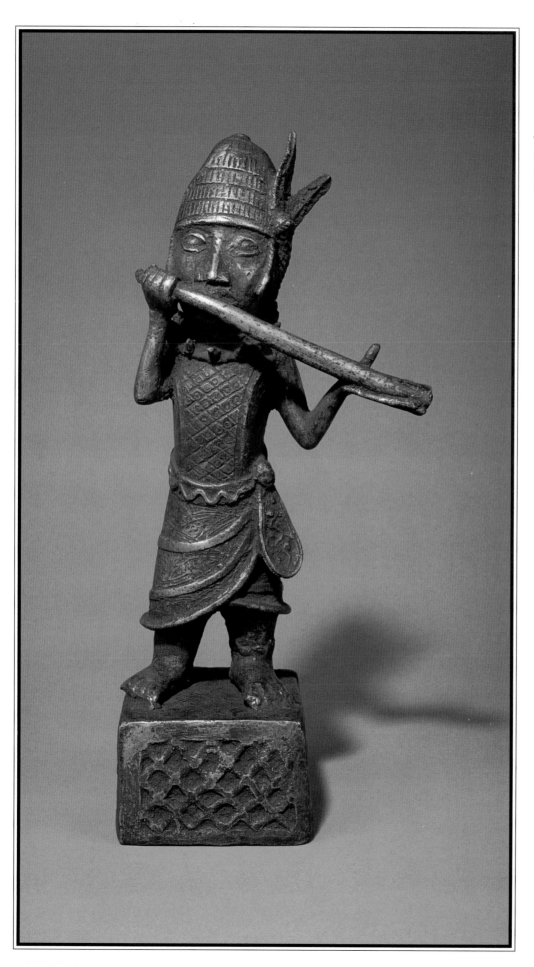

Trumpet player. 20th century.
$400-475.
Bronze, 13-1/4"
Nigeria

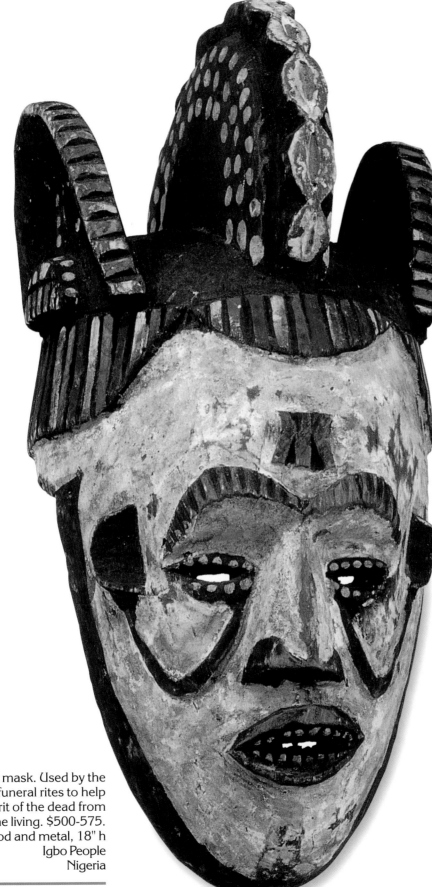

Maiden-spirit mask. Used by the
Mmwo society in funeral rites to help
keep the spirit of the dead from
disturbing the living. $500-575.
Polychrome wood and metal, 18" h
Igbo People
Nigeria

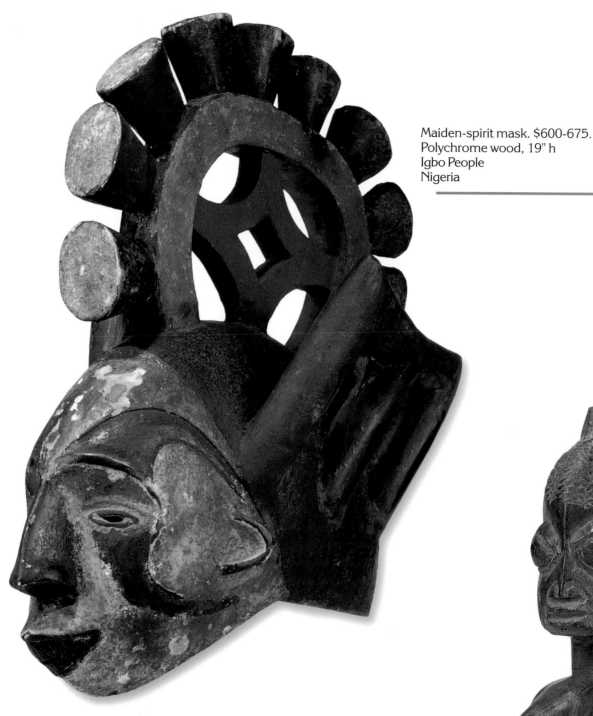

Maiden-spirit mask. $600-675.
Polychrome wood, 19" h
Igbo People
Nigeria

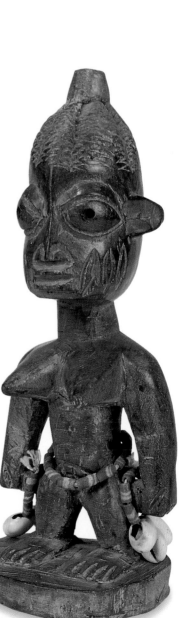

Ibeji twin. Twins were particularly valued in Yoruba society and, according to some sources, more frequent than in comparable American populations. If a twin died, the parents would commission a carving like this to become the resting place of the dead child's spirit. Food would be rubbed into the wood to feed the spirit, often resulting in obliterated features. $350-425.
Wood, beads, cowries, 11" h
Yoruba People
Nigeria

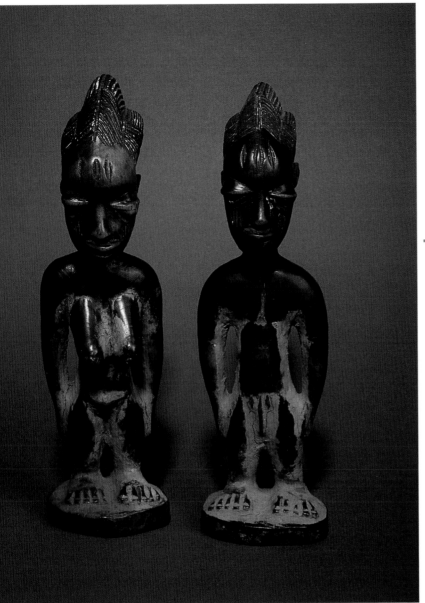

Male and female Ibeji twin statues. Rare.
Wood, 10-1/2"
Yoruba People
Nigeria.
Courtesy of the Hemingway African Gallery, New York.

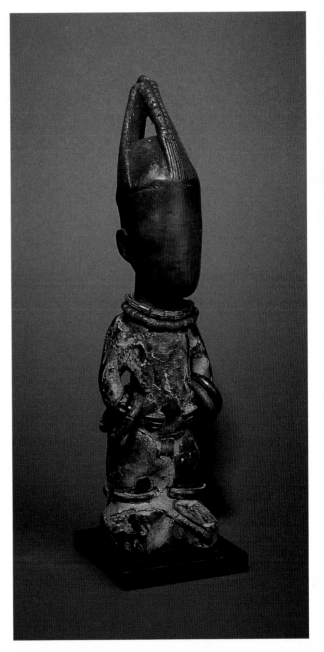

Ibeji twin with beads. The face is worn off from parent's affections. Rare.
Polychrome wood, beads, 10"
Yoruba People
Nigeria.
Courtesy of the Hemingway African Gallery, New York.

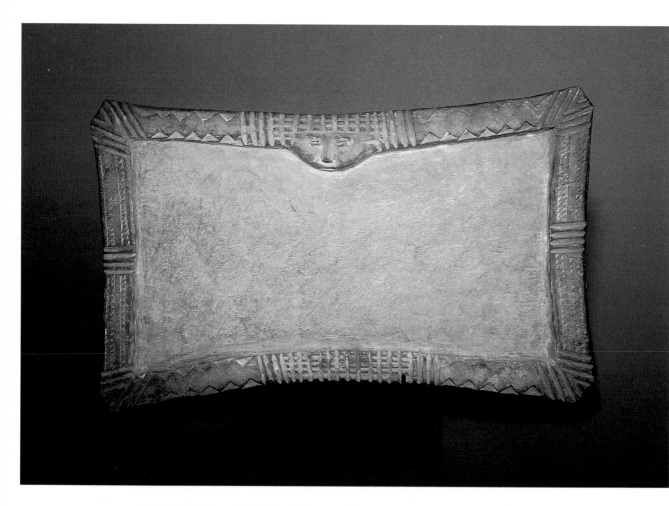

Divination board
called *okou-ifa,*
with a carved
border. Powder
(often flower) or
bones were plac[ed]
on the plate and
tapped. The
resulting positio[n]
allowed for divin[a]
tion. (see Segy,
ASS, p. 193)
Wood, 9" x 14-1[/2"]
Yoruba People
Nigeria
Courtesy of the
Hemingway Afri[can]
Gallery, New Yor[k.]

Divination
board.
Wood, 17" x 11-
1/2"
Yoruba People
Nigeria
Courtesy of the
Hemingway
African Gallery,
New York.

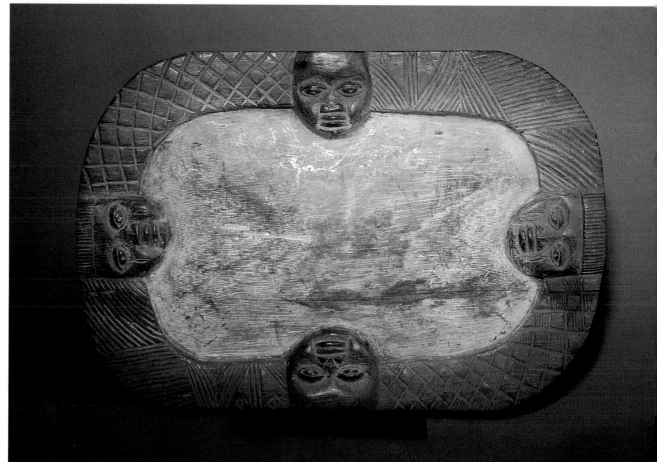

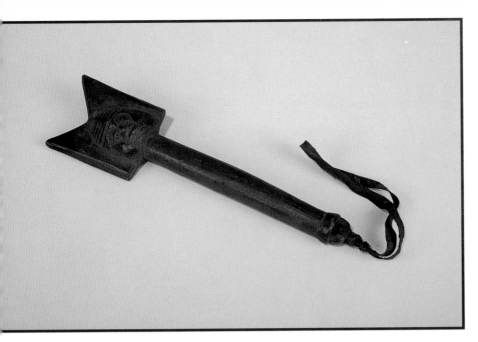

Shango staff, the *ose-Shango,* has a representation of Shango a god of lightning and legendary founder of the Yoruba nation. The form of this piece is most commonly that of the double axe, though some single axes are known. $400-475.
Wood, leather, 13" l.
Yoruba People
Nigeria

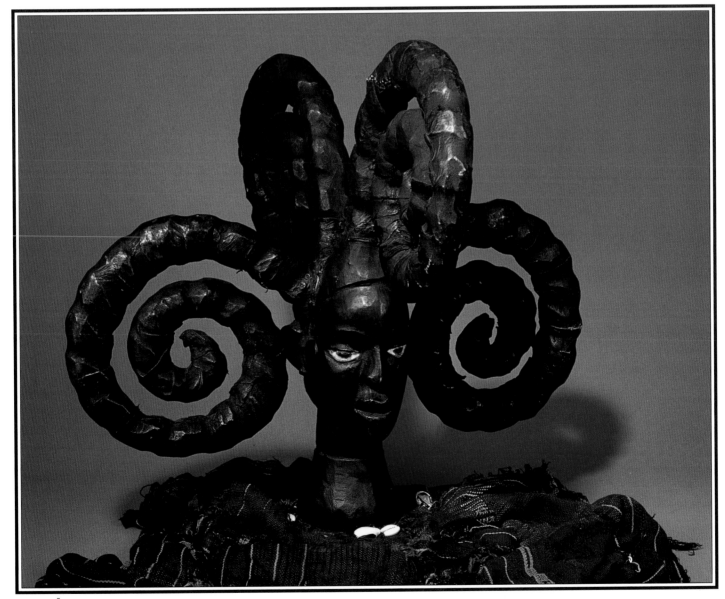

The Ekoi used skin covered headdresses and masks in burial ceremonies and secret society rituals. In earlier times they may have been covered with the skin of slaves, but more recently animal skins have sufficed. (Segy, *ASS, p. 204*). $925-1025.
Wood, skin, cowrie, 19-1/2" x 21-1/2"
Ekoi People, Nigeria

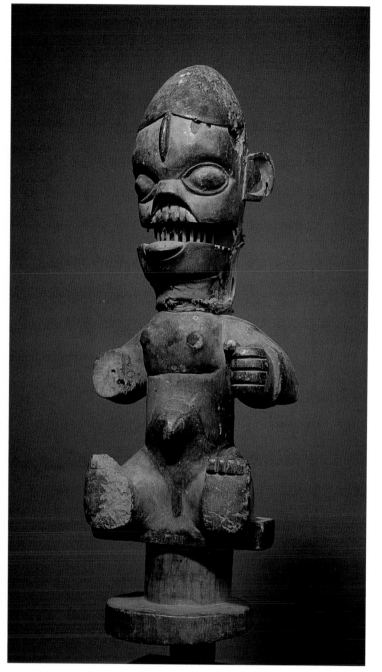

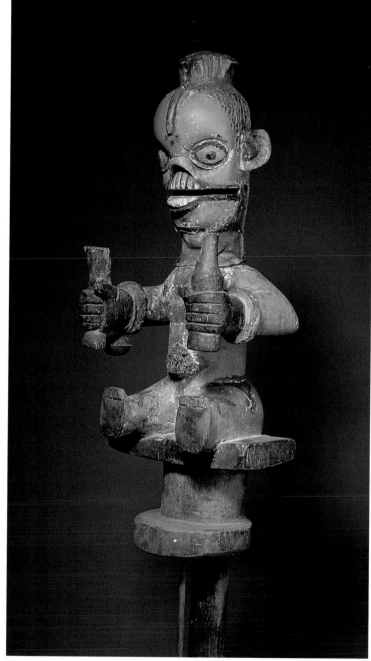

The articulated jaw of these Ogoni puppets are similar to those used on their masks. The movement is controlled through the rod they are carried on. The puppeteer is covered with fabric.
Polychrome wood
Ogoni People
Nigeria
Courtesy of the Hemingway African Gallery, New York.

Puppet with beer and glass.
Ogoni People
Nigeria
Courtesy of the Hemingway African Gallery, New York.

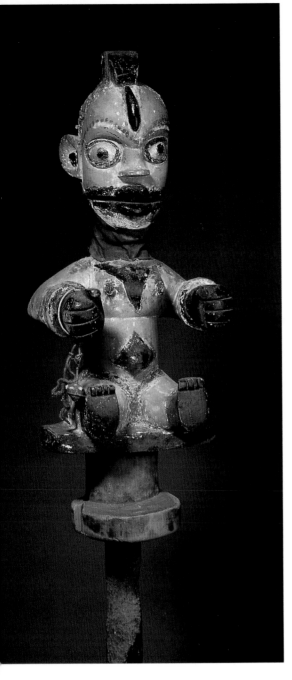

Puppet.
Ogoni People
Nigeria
Courtesy of the Hemingway African
Gallery, New York.

Old decoy, which was worn on the forehead of
the hunter.
Wood and leather, with beads.
Hausa Kingdom
Nigeria
Courtesy of the Hemingway African Gallery,
New York.

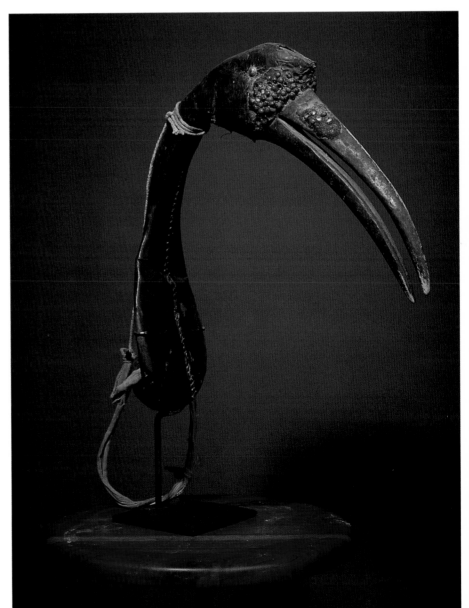

CAMEROON

The major tribal people of Cameroon include the Kirdi, Fulani, Ewondo, Duala, Bamileke, Bassa, Beti, Fang, Gbaya, Banso, and Tikar, combining for a national population of over 13.5 million people. Over half of the people practice African religions, thirty-three percent Christian, and sixteen percent Muslim. Hunters and gatherers were probably the first to inhabit the forests of Cameroon, and their descendants still live there. Bantu-speaking people moved into the region from the north, and, in the seventeenth, eighteenth, and nineteenth centuries, Muslim Fulani moved to Cameroon from the Niger basin. European trade began in the sixteenth century, and included the slave trade. Colonization took place in the late nineteenth century with Cameroon being divided between France, England and Germany. Germany's influence grew until the beginnings of World War I, when France and England invaded the German colony and seized control. In 1919 France and England divided the nation among the two nations, a move which the League of Nations confirmed in 1922. In 1960, French Cameroon received its independence. The southern part of British Cameroon voted to join the Republic of Cameroon the following year, though the French and English parts maintained governments that were largely separate until 1972.

Based on information from the University of Iowa, Art & Life in Africa project.

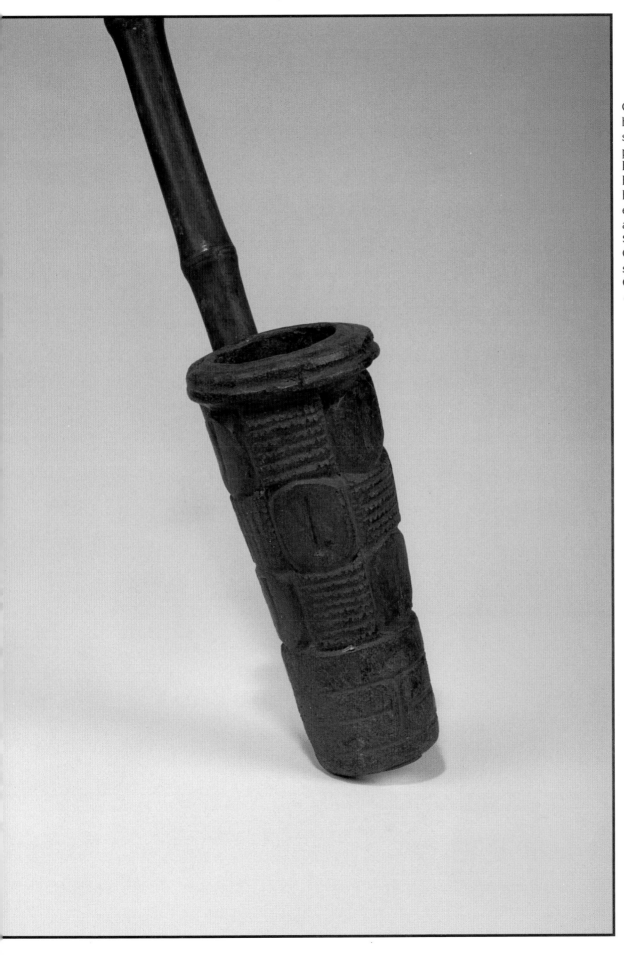

Ceramic pipes have
been found among
several Cameroon
people including the
Bali, Bamum,
Bamileke, and
Bamessing. This
example is incised with
an interesting pattern.
$400-450.
Ceramic bowl, 7", reed
stem (overall 36" long)
Cameroon

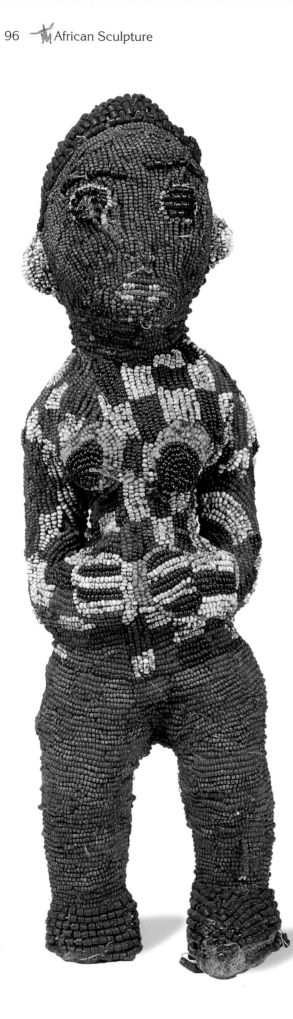

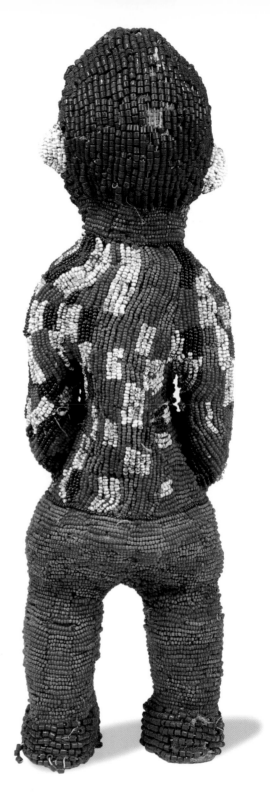

Bead covered figurines and ancestor figures are typical of the Bamum People. This example is completely covered in colorful patterns of glass beads. $600-675.
Wood and beads, 18" h.
Bamum People
Cameroon

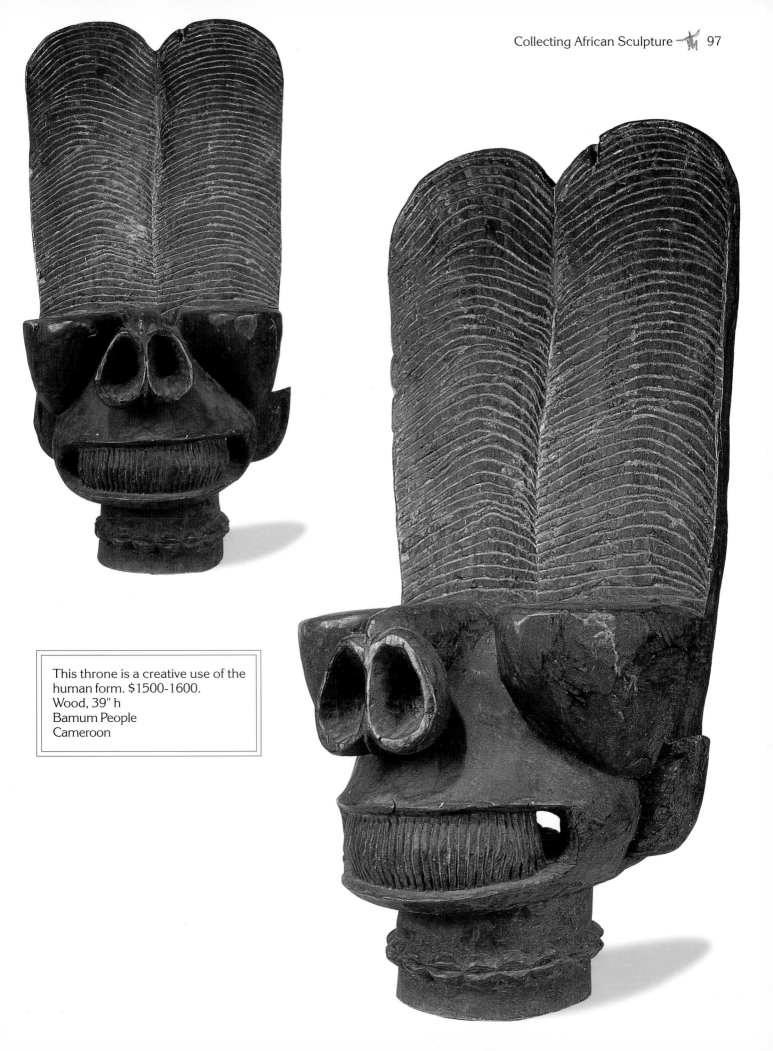

This throne is a creative use of the
human form. $1500-1600.
Wood, 39" h
Bamum People
Cameroon

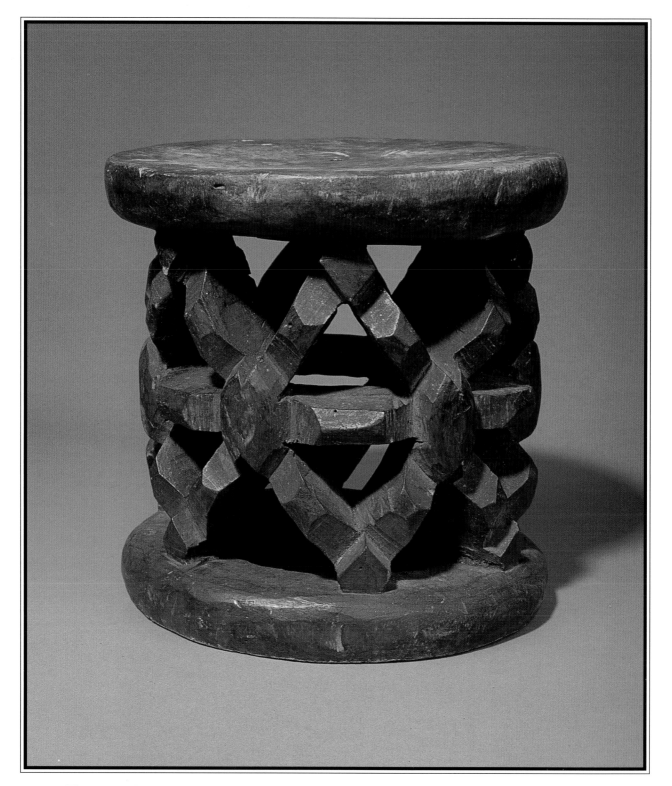

These round stools with intricately carved supports are
typical of the Bamum People. The supports are
usually in animal, as this spider stool, or human
forms. $400-425.
Wood, 10" tall
Bamum People
Cameroon

Trumpet in a human form with nicely carved
head and decorated bell. $300-350.
Wood, 25" long
Bamum People
Cameroon

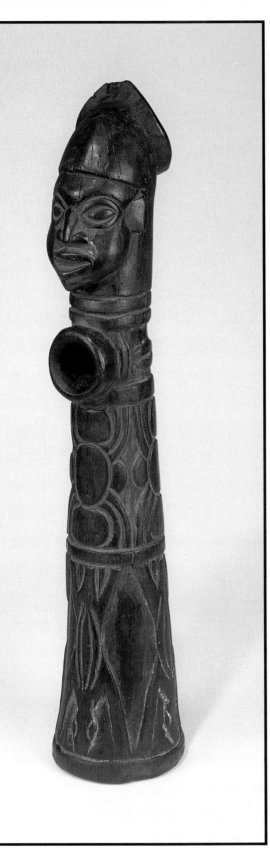

The Babanki People are known for their carvings in the
round, often used in stools. This spider mask uses the
same techniques in its round, intricately carved, pierced
crown (difficult to see because it is filled with fabric in this
photograph). $450-525.
Wood, 15" h
Babanki People
Cameroon

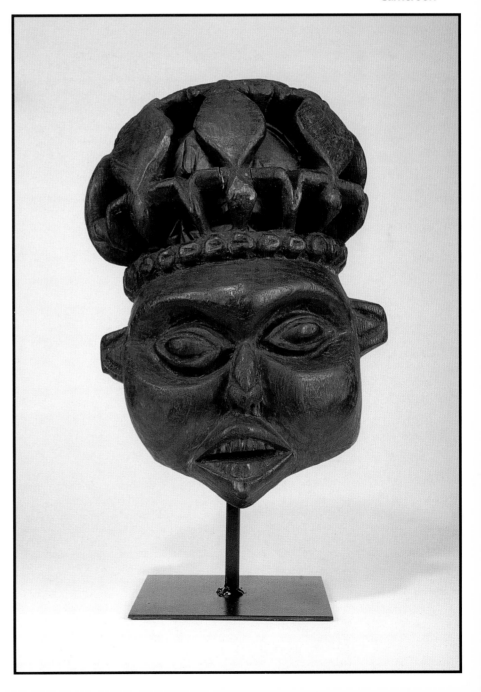

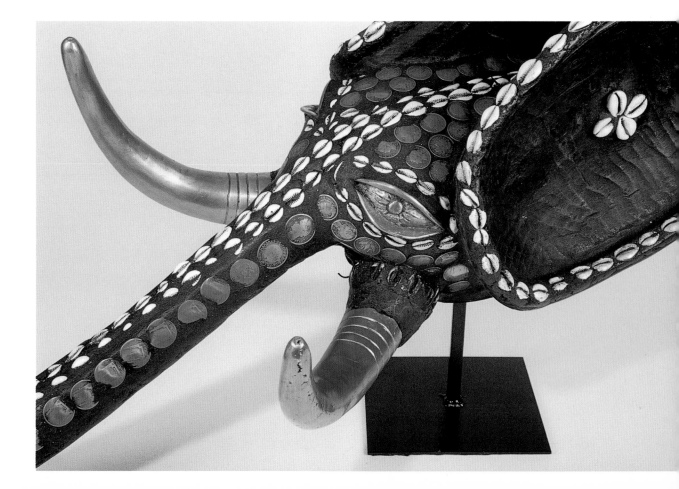

The casting skills of the Tikar people are evident in this early 20th century elephant icon. The head is carved of wood with cast brass trunk tip, tusks, and eyes. Embedded in the wood are cowrie and coins to give this large piece an dramatic character. $1600-1700.
Wood, cast brass, cowries, and coins, 42" l
Tikar People
Cameroon

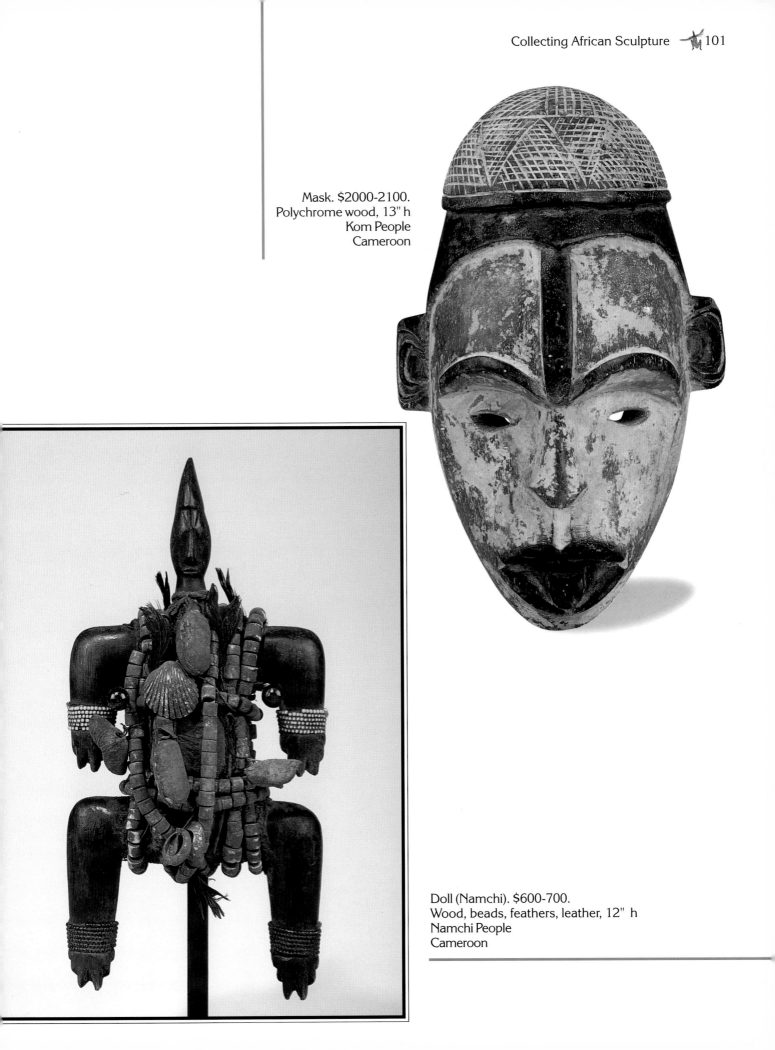

Mask. $2000-2100.
Polychrome wood, 13" h
Kom People
Cameroon

Doll (Namchi). $600-700.
Wood, beads, feathers, leather, 12" h
Namchi People
Cameroon

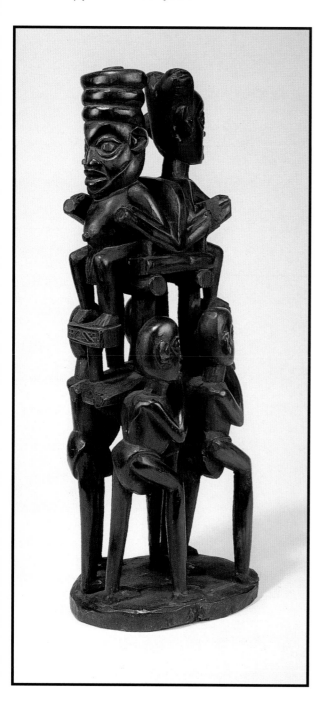

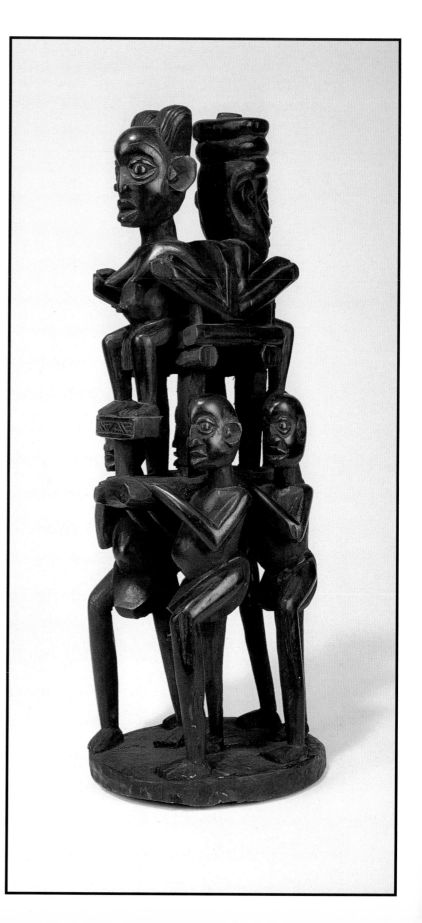

Intricately carved contemporary
sculpture depicting a queen and king
being carried by porters in procession.
$350-400.
Wood, 18" h.
Cameroon

GABON

This central African nation is home to the Fang, Eshira, Bateke, and Bopounou. It was settled by Bantu-speaking peoples long before European contact and the archeological evidence shows that it developed a rich culture. First contact was with the Portuguese in the 1400s. American missionaries established a mission there in the mid-1800s and the French colonized it in the late nineteenth century, making it a part of French Equatorial Africa in 1910. The nation received its independence in 1960.

Of the 1.2 million citizens, sixty percent are Christian, thirty-nine percent practice African religion, and one percent are Muslim.

Based on information from the University of Iowa, Art & Life in Africa project.

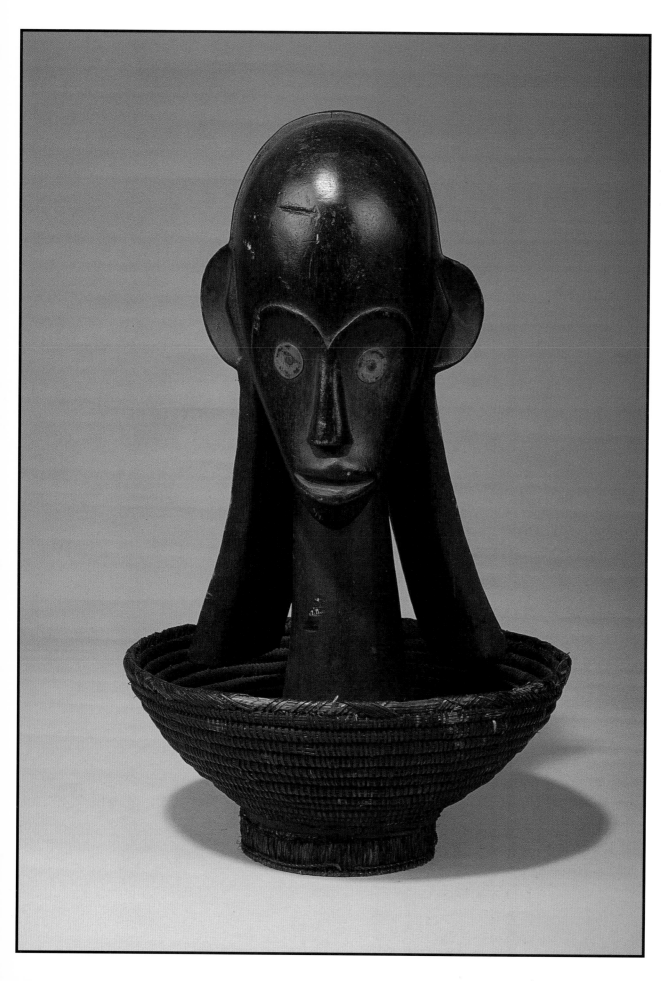

Funerary basket $82
925.
Wood, raffia 16" h
Kota People
Gabon

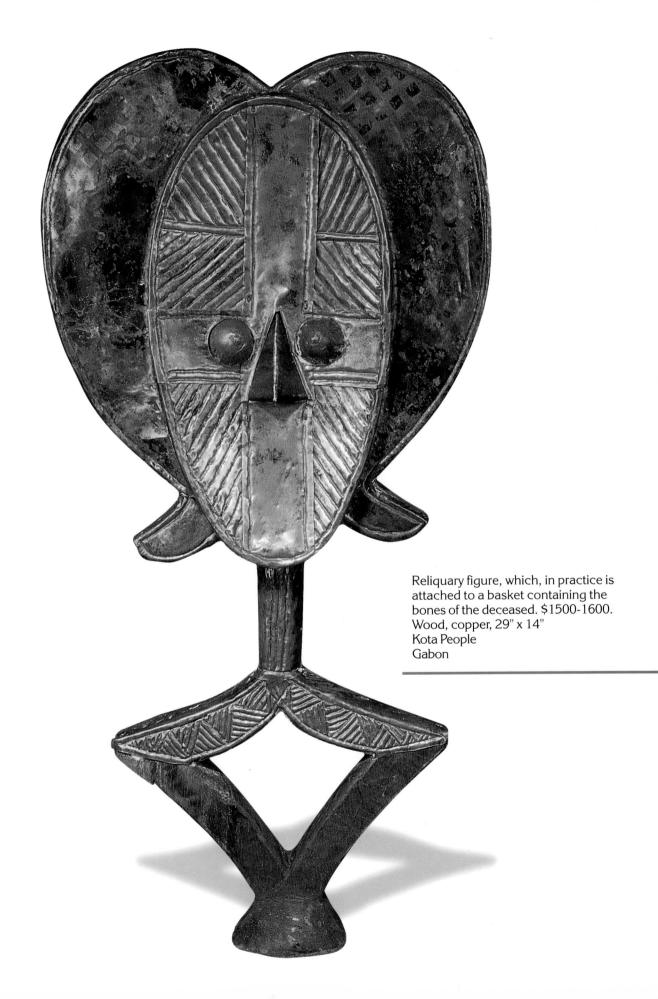

Reliquary figure, which, in practice is
attached to a basket containing the
bones of the deceased. $1500-1600.
Wood, copper, 29" x 14"
Kota People
Gabon

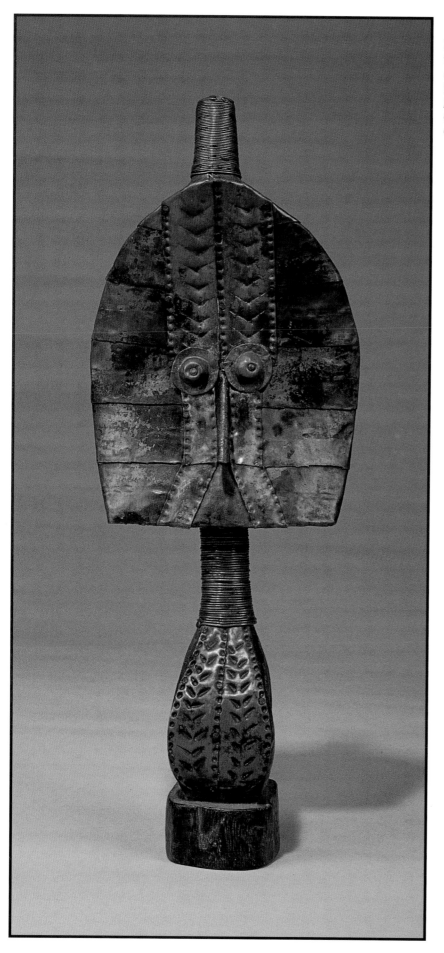

Funerary figure. Serving the same function as the larger Kota figure above, this is usually attributed to the Ossyeba People, though there is some disagreement about this. $600-700. Metal, wood, nails 14" h.
Ossyeba or Kota People
Gabon

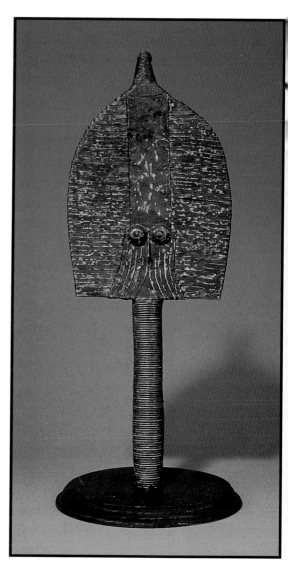

Funerary figure, which, in practice, is attached to a basket containing the bones of the deceased. $700-800. Wood, copper wire, 20" h
Ossyeba or Kota People
Gabon

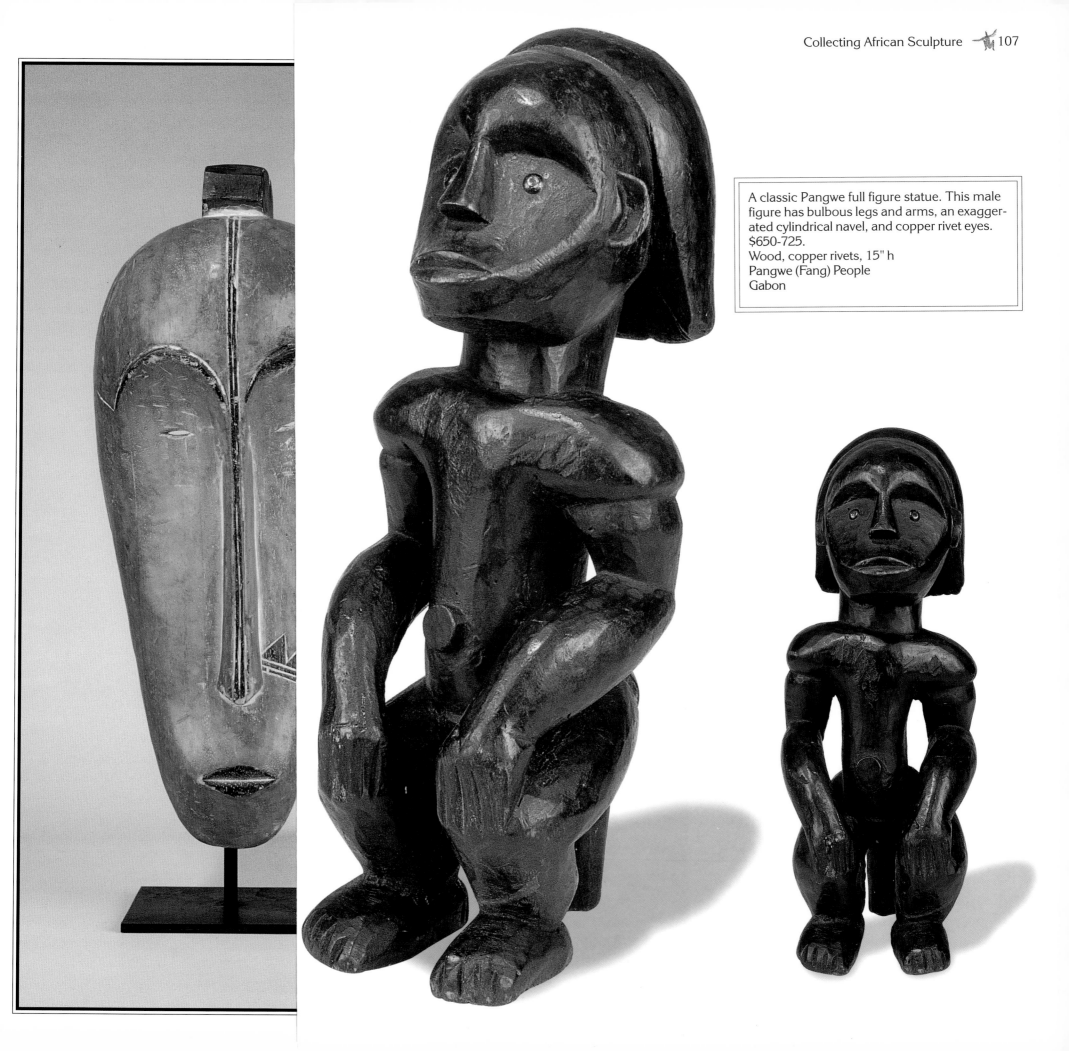

A classic Pangwe full figure statue. This male figure has bulbous legs and arms, an exaggerated cylindrical navel, and copper rivet eyes.
$650-725.
Wood, copper rivets, 15" h
Pangwe (Fang) People
Gabon

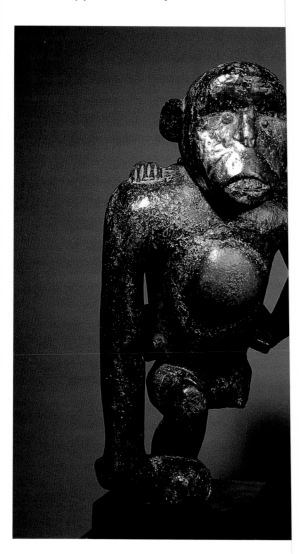

Ape and child sculpture.
Pangwe (Fang) People
Gabon.
Courtesy of the Hemingway African Galle[...]
New York.

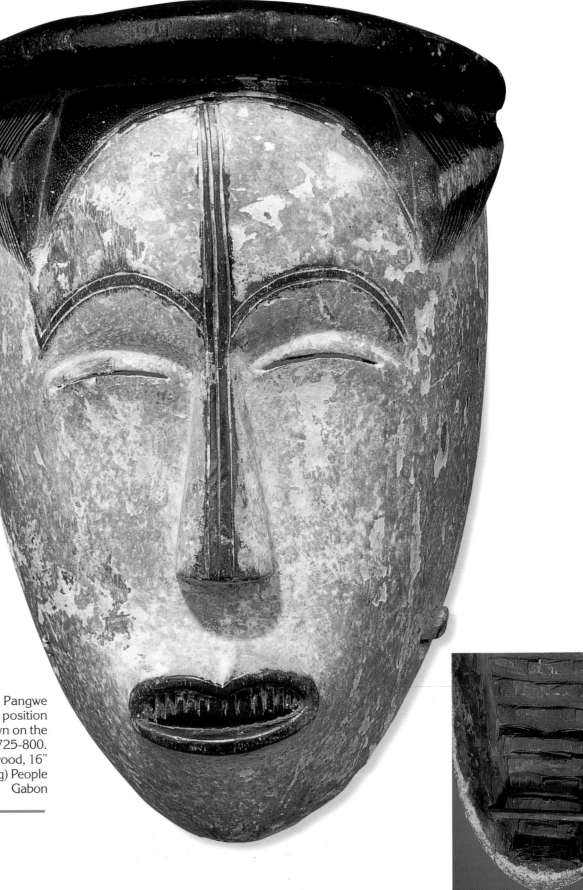

Another example of a Pangwe
mask, this one held in position
by the wearer biting down on the
bar in the rear. $725-800.
Polychrome wood, 16"
Pangwe (Fang) People
Gabon

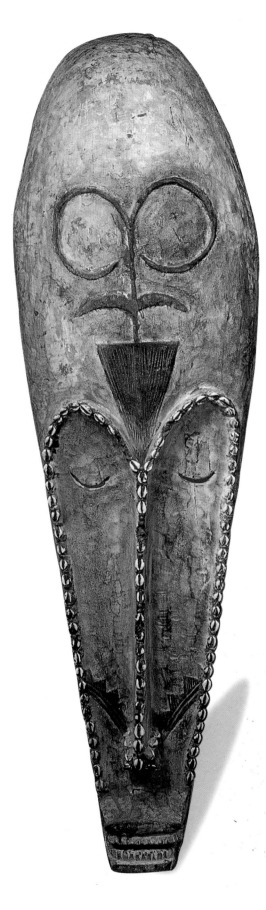

Large initiation mask. $1500-1600.
Polychrome wood, cowry shells and seed pods, 58".
Pangwe (Fang) People
Gabon

Mask.
Polychrome wood and raffia, 12"
Pangwe (Fang) People
Gabon/Congo
Courtesy of the Hemingway African Gallery,
New York.

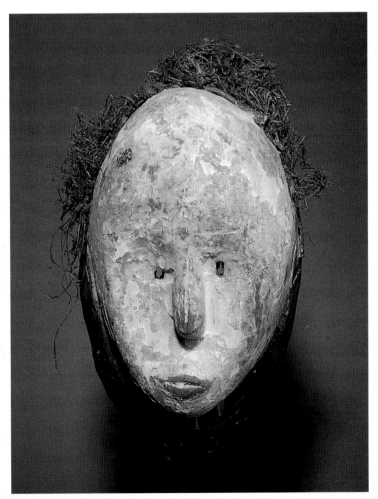

A typical mask of the people in the Ogowe River area. The hairdo is carefully carved to represent the customs of the M'Pongwe. The wooden breast plate makes up most of its height. Called a *dumu* it represents a female spirit guardian in funeral and initiation rites, and was danced in ancestor cults and at the full moon (Segy, *MAB, fig. 194*). $425-500.
Polychrome wood, 13" h
M'Pongwe (Punu) People
Gabon

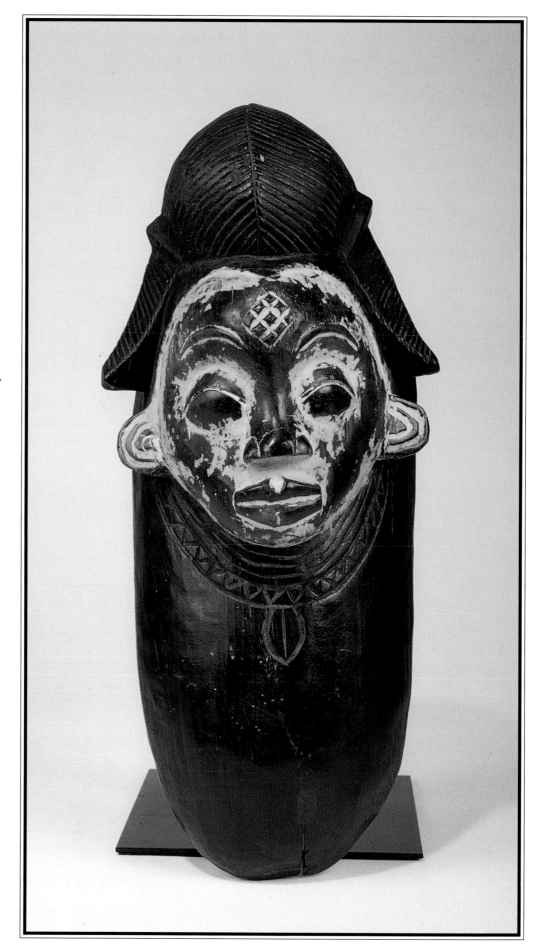

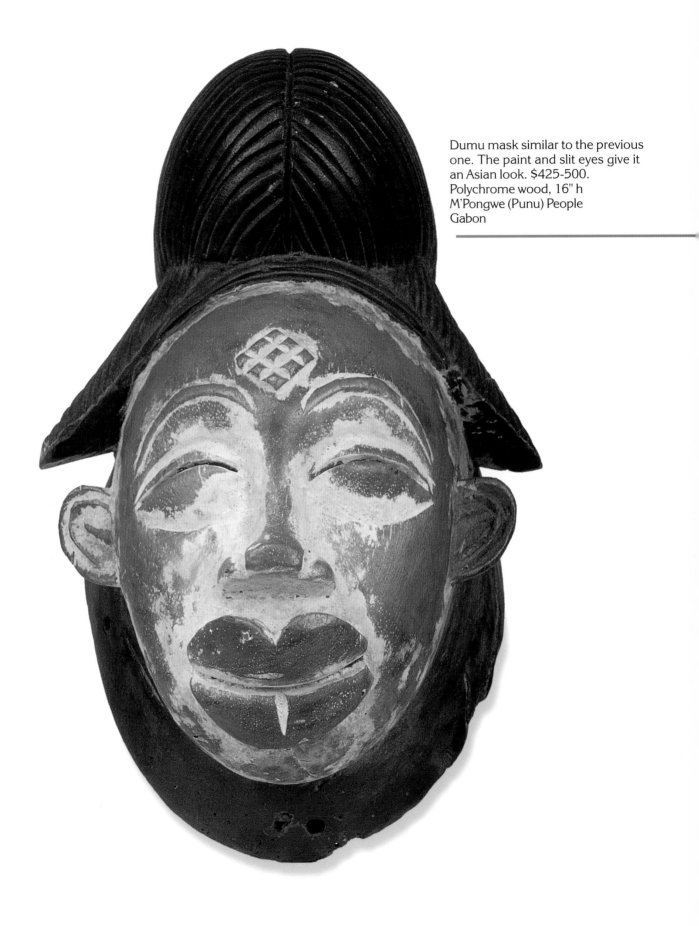

Dumu mask similar to the previous one. The paint and slit eyes give it an Asian look. $425-500.
Polychrome wood, 16" h
M'Pongwe (Punu) People
Gabon

CONGO

Congo actually refers to two countries, both of which call their citizens "Congolese." The smaller of the two has a population of 2.5 million and about 350,000 square kilometers of area. Its capitol is Brazzaville. Principle people of Congo are the Kongo, the Sanga, the M'bochi, and the Teke. The population is fifty percent Christian, forty-eight percent African religion, and two percent Muslim. The early history of Congo revolves around three ancient kingdoms: the Kongo, dating back to the 1300s, the Loango, and the Teke, which as Middle Congo, became part of French Equatorial Africa in the late 1800s. Independence came in 1960.

The larger country, usually denoted as Congo (Zaire), covers 2.3 million square kilometers, and has a population of over 44 million people. They are predominately Christian (seventy percent), with twenty percent following African religion, and ten percent Muslim. The principal peoples residing in Congo (Zaire) include the Azande, Chokwe, Songo, Kongo, Kuba, Lunda, and Bembe. The area has a diverse history, ranging from hunter-gatherer societies to highly organized agriculture- and trade-based communities. The Kongo Kingdom was established in the 1200s and grew in power for the next four hundred years. The Luba Empire, an era known for its sculpture, poetry, and music, followed it in the mid-1600s. Relations with Europe started in the early 1500s. In 1885, the Conference of Berlin recognized Belgium King Leopold's claim of rulership. Independence from Belgium came in 1960. The country went by the name of Zaire for many of the ensuing years, until Lawrence Kabila took over the reigns of government in 1997 and changed the name to the Democratic Republic of the Congo.

Based on information from the University of Iowa, Art & Life in Africa project.

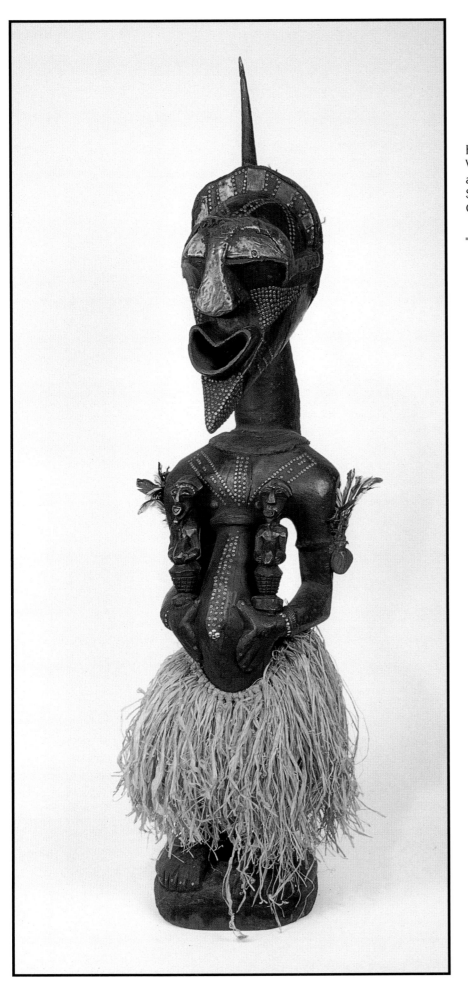

House charm. $2400-2500.
Wood, raffia, copper nails, metal sheathing,
and feathers. 61" h.
Songye People
Congo

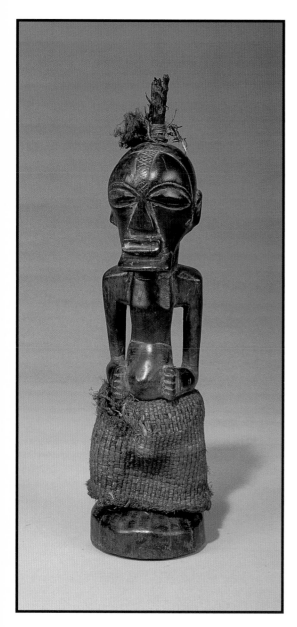

Charm figure.
$250-350
Wood, burlap, 10" h.
Songye People
Congo

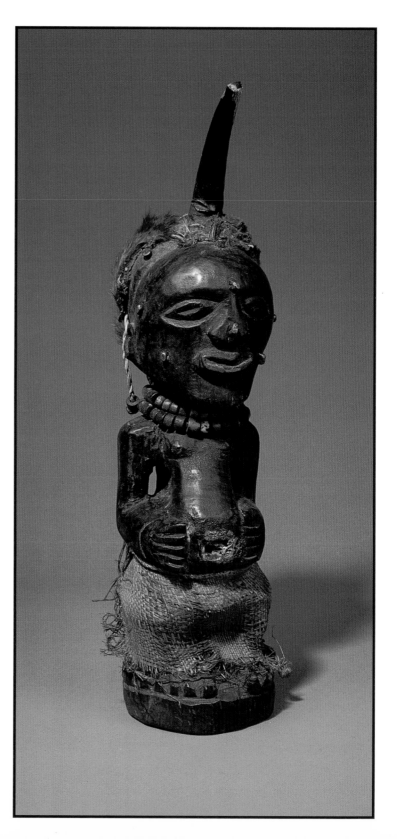

Fetish figure. $475-525
Wood, burlap, animal hide, with copper
nails and ceramic beads, 19-1/2"
Songye People
Congo.

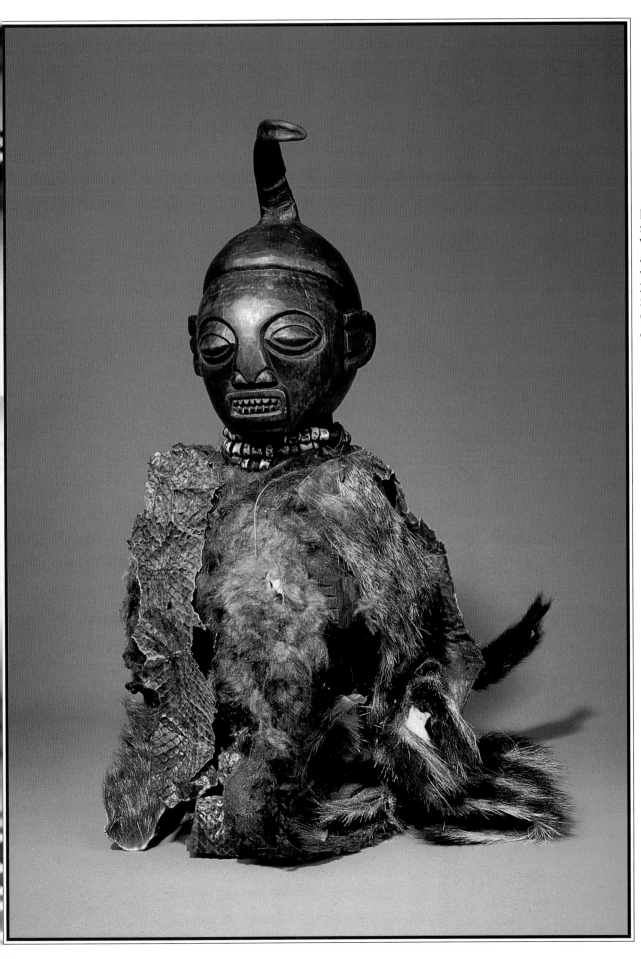

Fetish figure.
$2500-2600.
Wood, snake skin,
and animal hide
with bone beads.
23-1/2".
Songye People
Congo

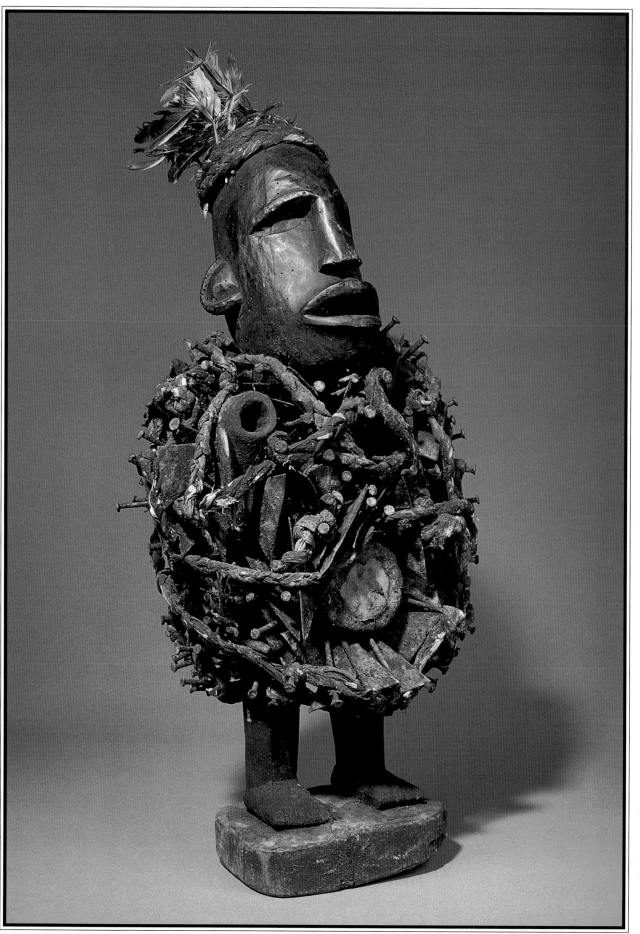

Fetish figure.
$3000-3500.
Wood, fiber rope,
nails, metal, hide an
feathers. 27".
Songye People
Congo

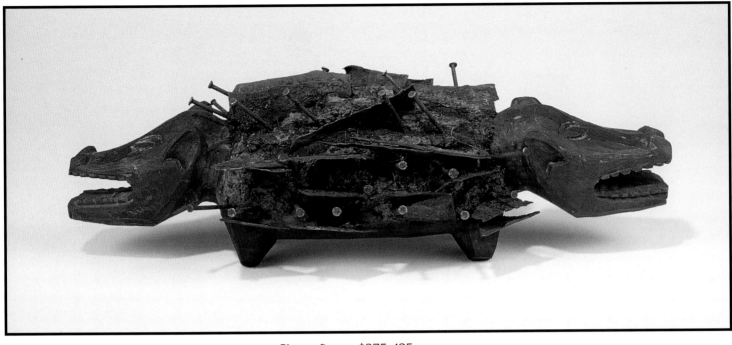

Charm figure. $375-425.
Wood, nails, metal blades, 20" l
Songye People
Congo

An interest woven mask with applied
wood and cowrie features. $300-325
Basket, wood, cowries, 9 1/2 dia
Songye People
Congo

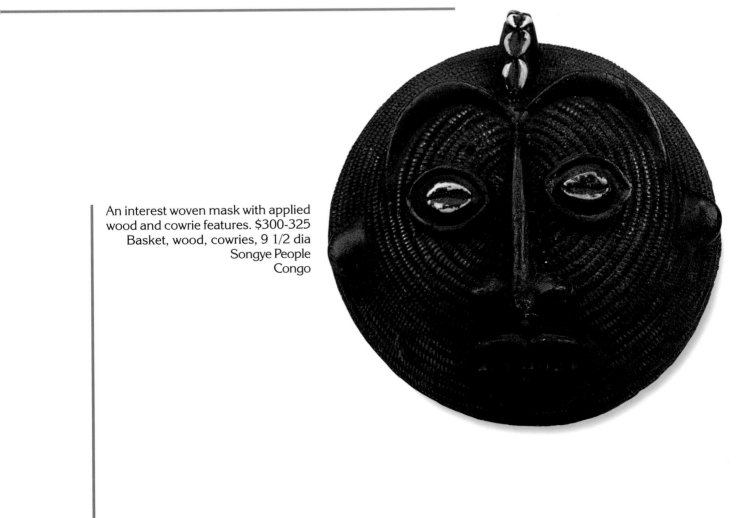

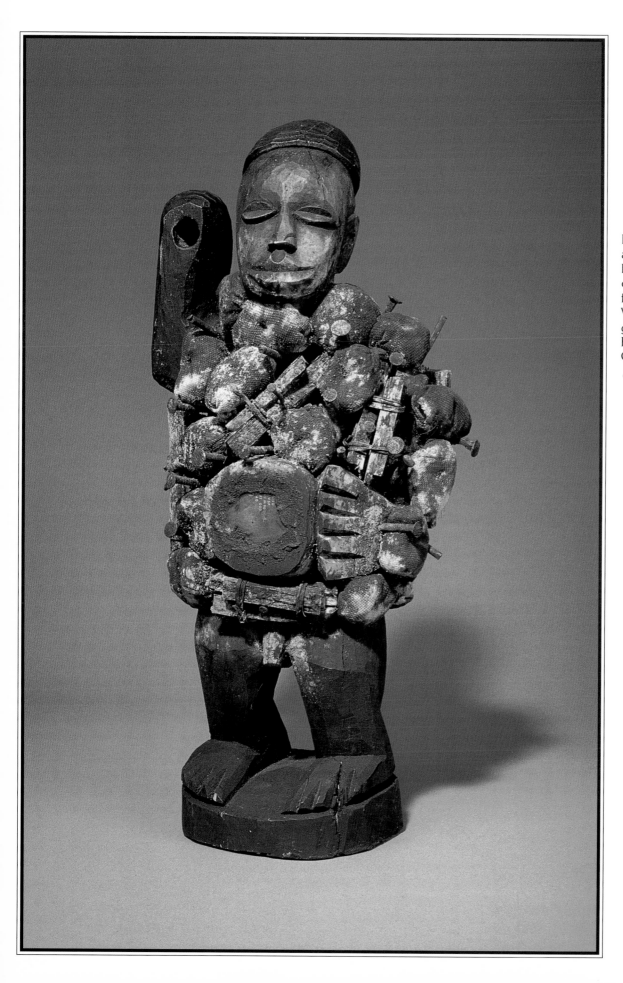

Fetish. The upraised arm probably once held a dagger, a common Bakongo form. $2600-3000. Wood, fabric packets, glass, nails, rope. 20". Kongo People Congo.

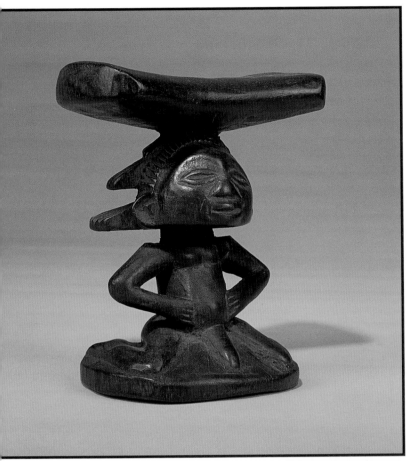

A male figure supports this headrest. He sports the double chignon hairdo typical of the Luba. $450-500.
Wood, 9" h
Luba People
Congo

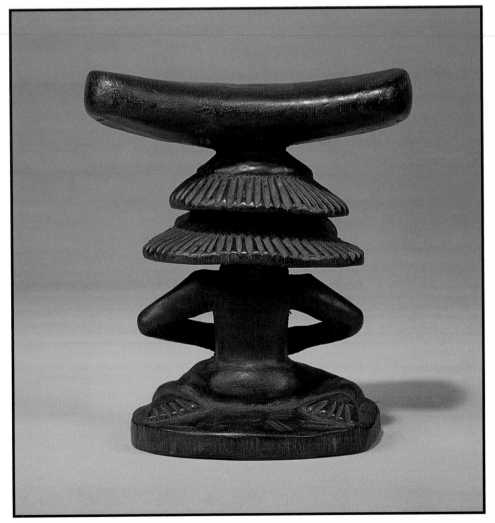

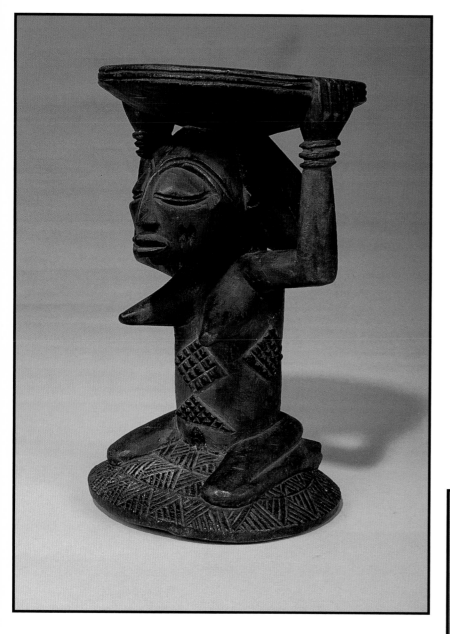

The figure holding the seat of this stool is wonderfully carved from the trunk of a tree. She has a Luba hairdo and cicatrix marks carved on her body. $450-500.
Wood, 9" h
Luba People
Congo

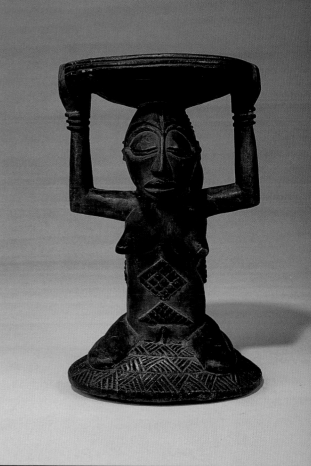

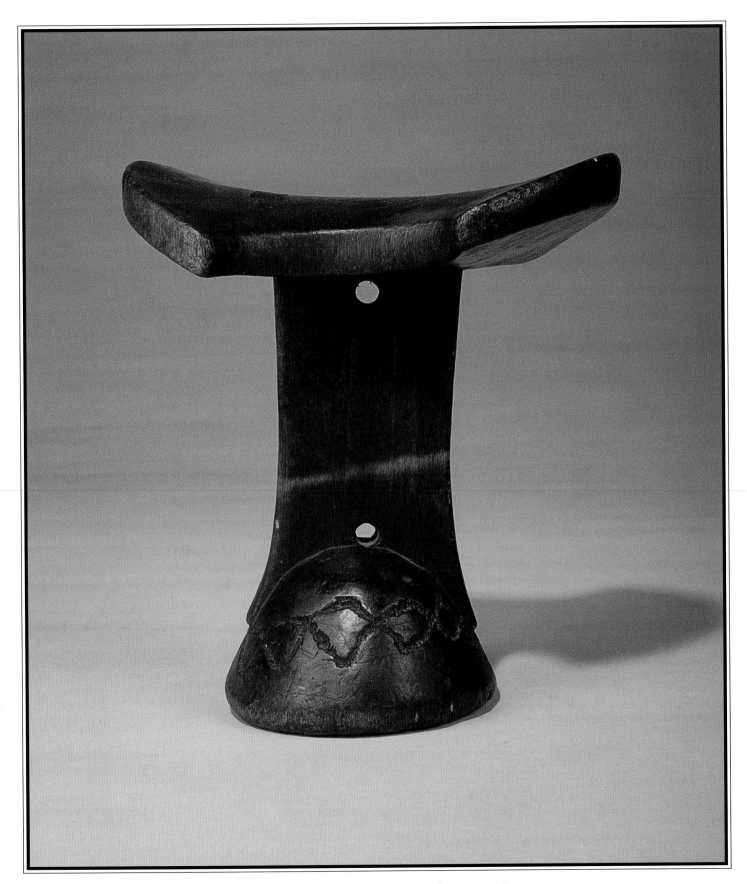

Headrest with incised carving and an interesting
asymmetrical head piece. $275-300
Wood, 7" h
Luba People
Congo

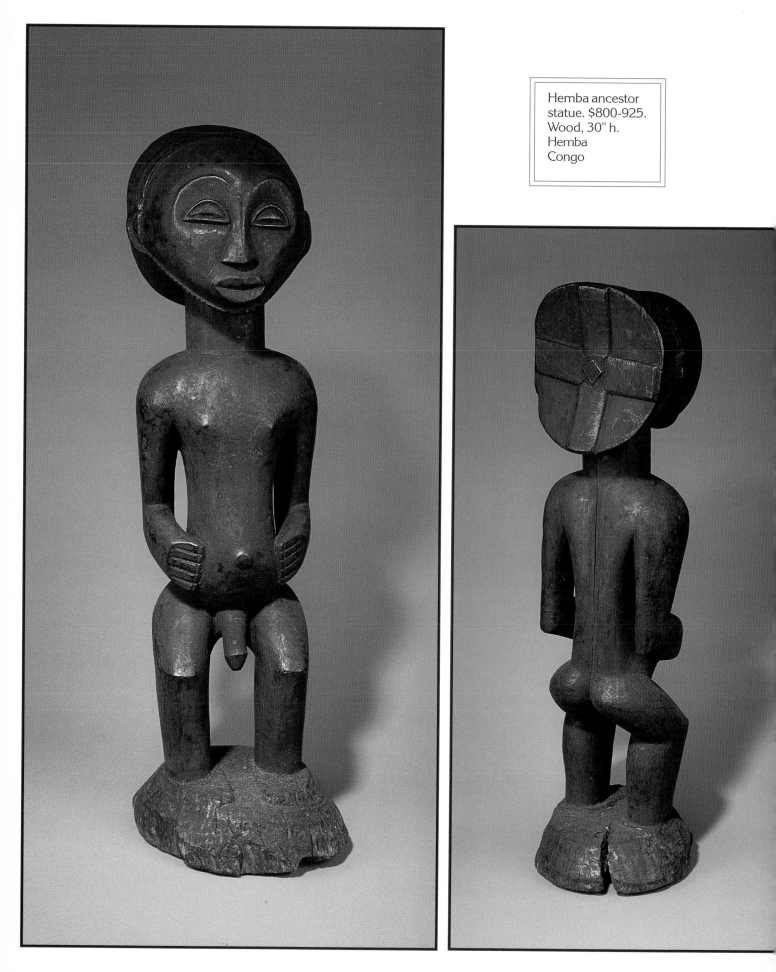

Hemba ancestor
statue. $800-925.
Wood, 30" h.
Hemba
Congo

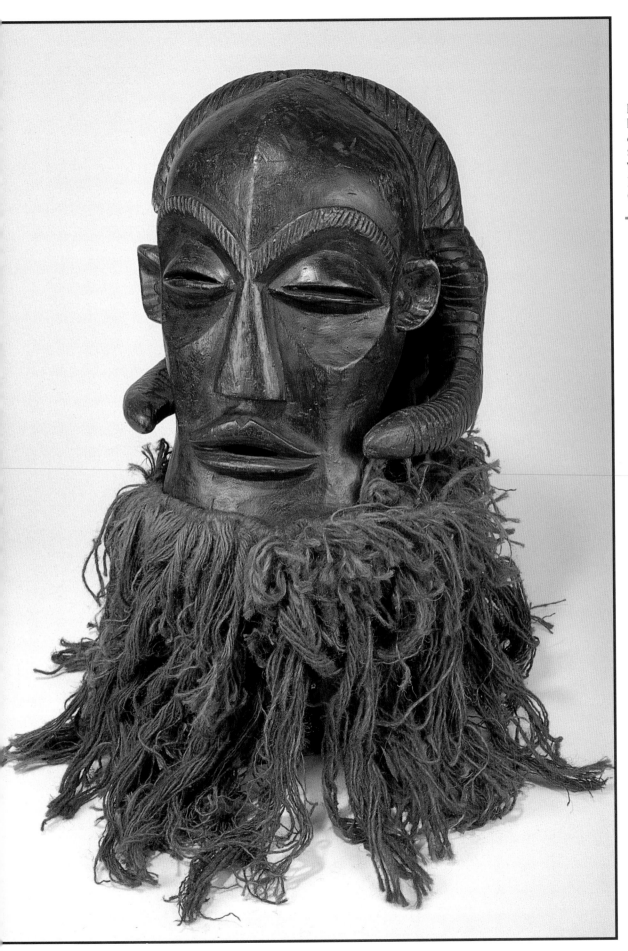

Helmet mask with
horns that come
down beside the face.
$600-650.
Wood, hemp, 16" h
Luba People
Congo

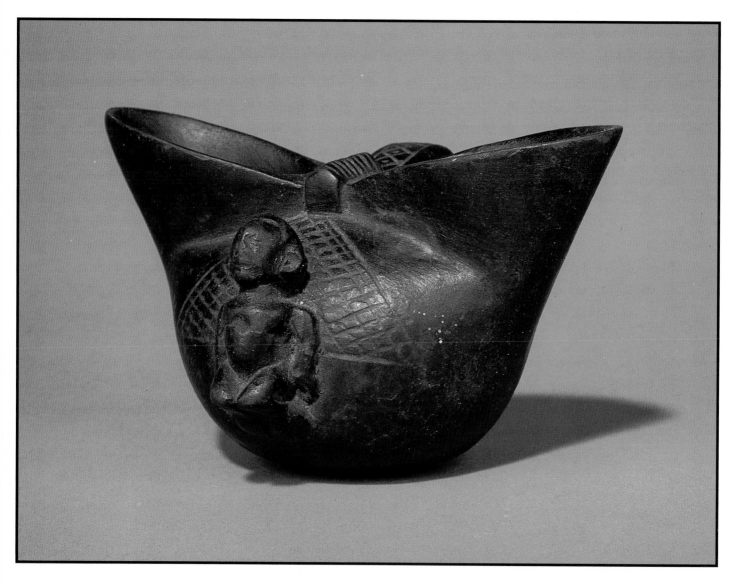

Palm wine cup. The carved shape creates a figure eight at the top with two openings. It was used for weddings with the bride drinking from one side and the groom from the other. On one side is a figure and on the other a carved handle. $175-200.
Wood, 3-1/2 x 5-3/4 x 4-1/2".
Yaka People
Congo

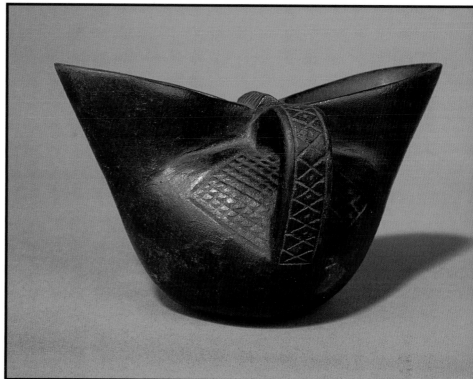

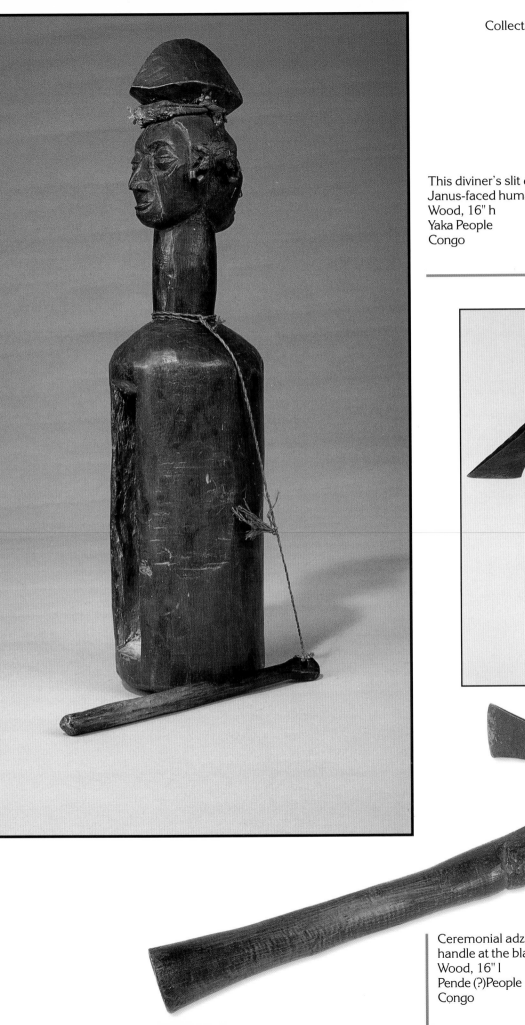

This diviner's slit drum is surmounted by a Janus-faced human figure. $350-400.
Wood, 16" h
Yaka People
Congo

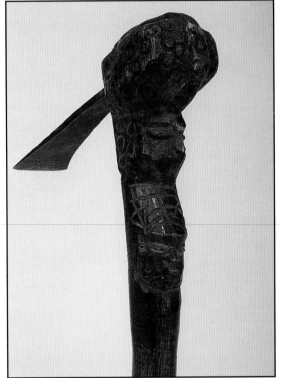

Ceremonial adze with two faces carved into the handle at the blade. $300-350.
Wood, 16" l
Pende (?)People
Congo

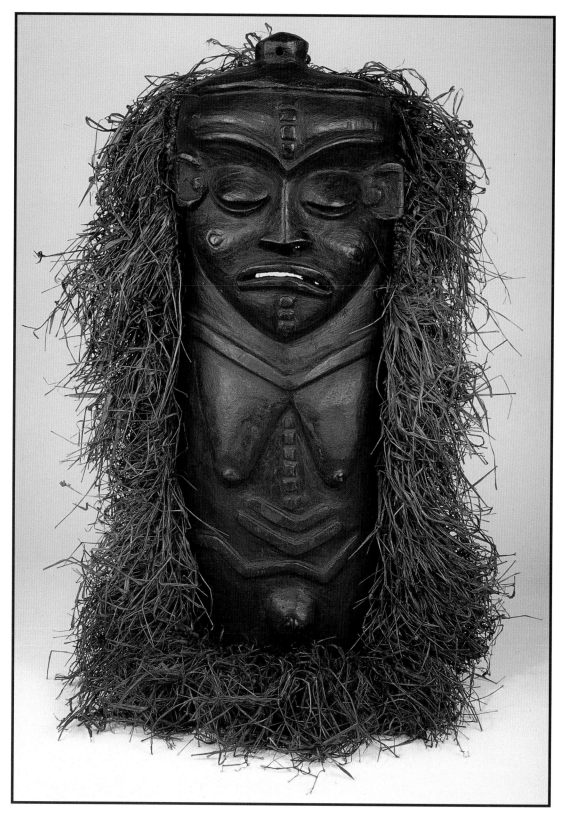

Large hand-held mask. $575-600.
Wood, natural fibers, grass, 35" h.
Pende People
Congo

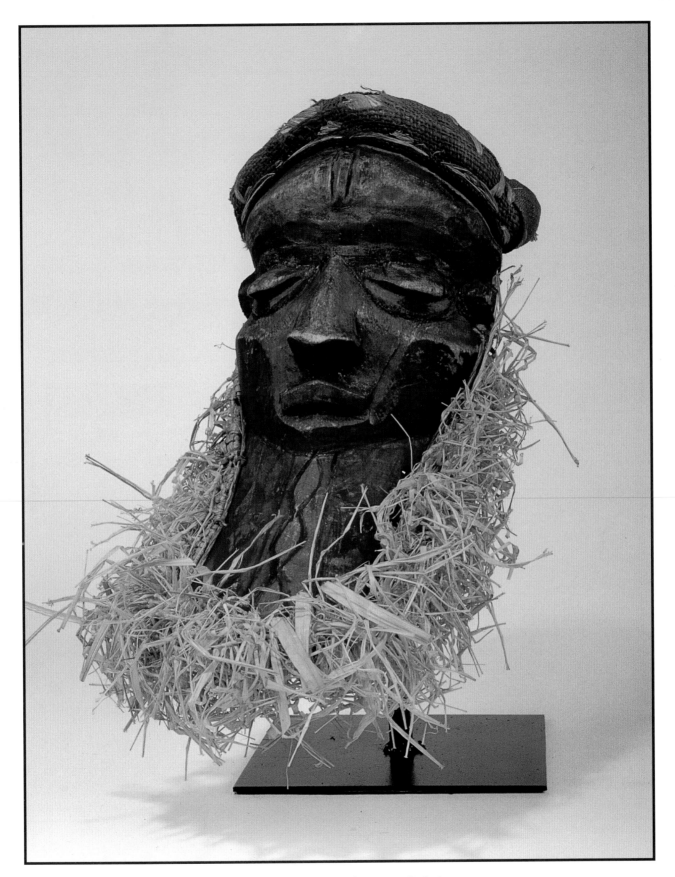

Mbuya mask, which in this form is called *giwoyo,*
muyombo, or *ginjinga.* $375-425.
Wood, raffia, burlap, 16" h
Pende People
Congo

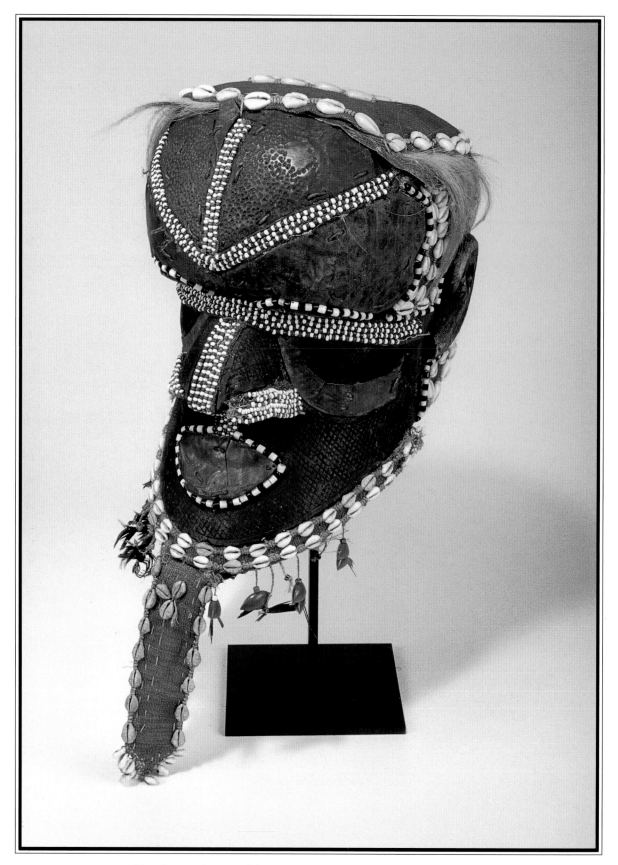

Bomba mask, one of the more commonly recognized masks of the
Kuba. It is thought to represent the original people. $825-900.
Wood, copper, beads, raffia, pods, and cowrie shells, 25" h
Kuba People
Congo

The geometrical designs of the woven raffia cloth reflect the patterns used in some Kuba carving. Many unique and beautiful patterns are available. $95-100.
Dyed raffia, 27" x 25"
Kuba People
Congo

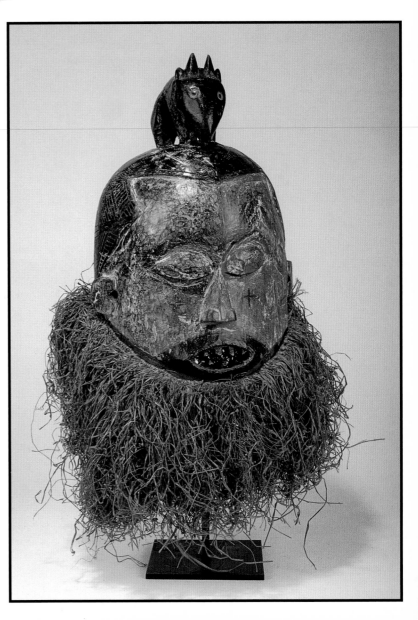

Hembe helmet mask, surmounted by an animal figure. These sometimes appear with a human figure or an abstract shape. $500-550.
Wood, Raffia, 20" tall
Suku
Congo

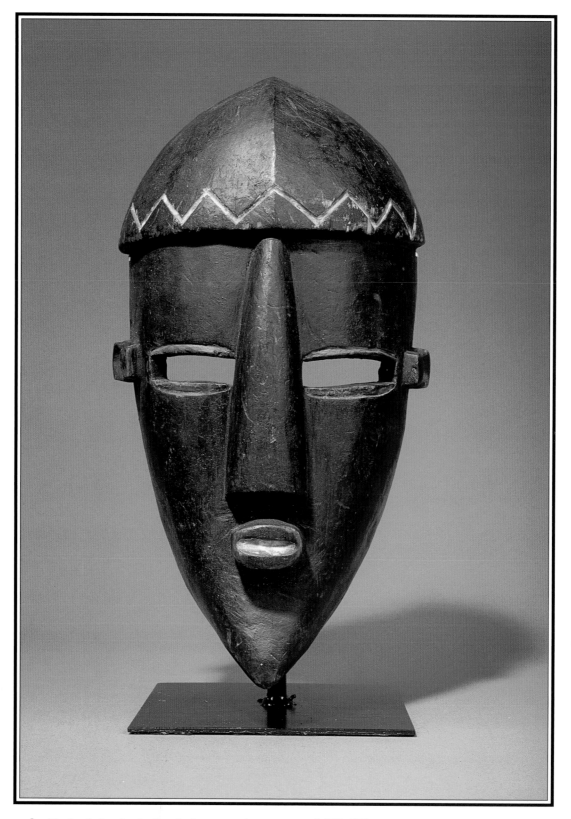

Mask of simple design. Luluwa masks are rare. $400-425.
Polychrome wood, 15" h
Luluwa People
Congo

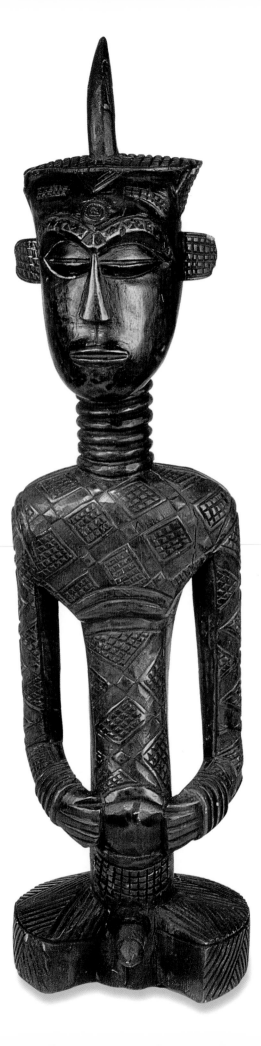

Statue, with tribal hairdo and scarification. $425-500.
Wood, 36" h
Ndengese People
Congo

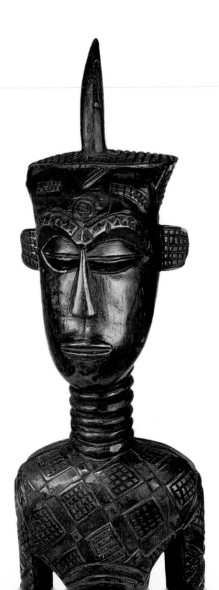

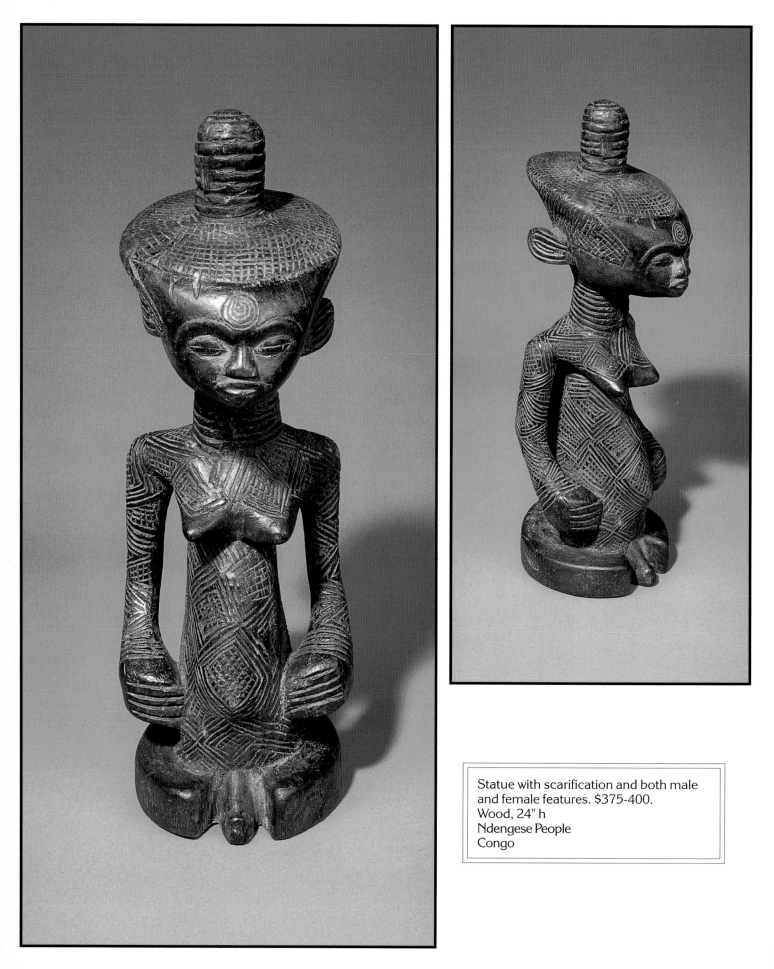

Statue with scarification and both male and female features. $375-400.
Wood, 24" h
Ndengese People
Congo

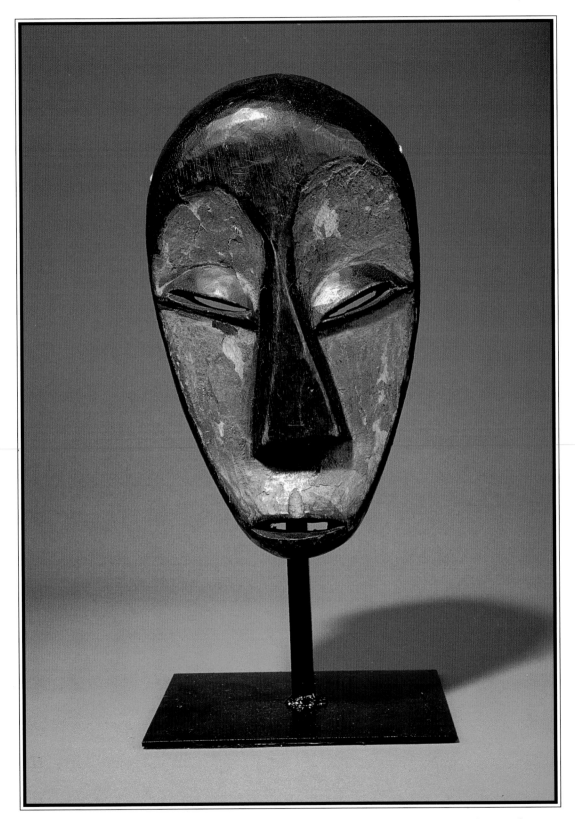

Lukwaklongo mask, of the second highest level of their hierarchical society. Its simple ovoid shape, well-formed eye lids, angular nose, and small mouth give a strong abstract beauty. Often this mask had a raffia beard attached and will be found with the beard or with holes where it would be attached. $300-325.
Wood, 11" h.
Lega People
Congo

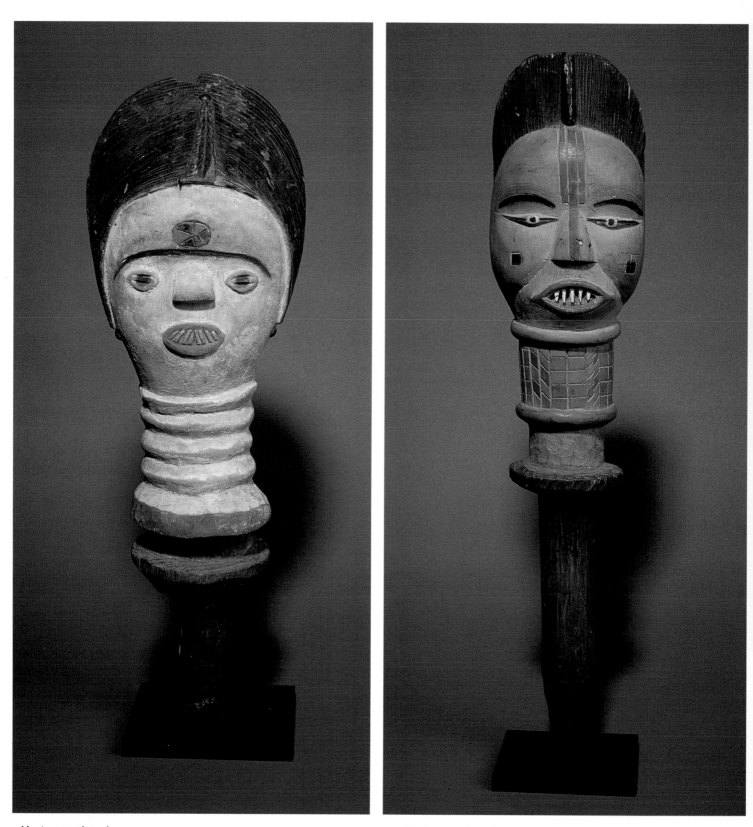

Marionette head.
Polychrome wood, 17" overall
Kuyu People
Congo
Courtesy of the Hemingway African Gallery, New York.

Marionette head.
Polychrome wood, 17" overall
Kuyu People
Congo
Courtesy of the Hemingway African Gallery, New York.

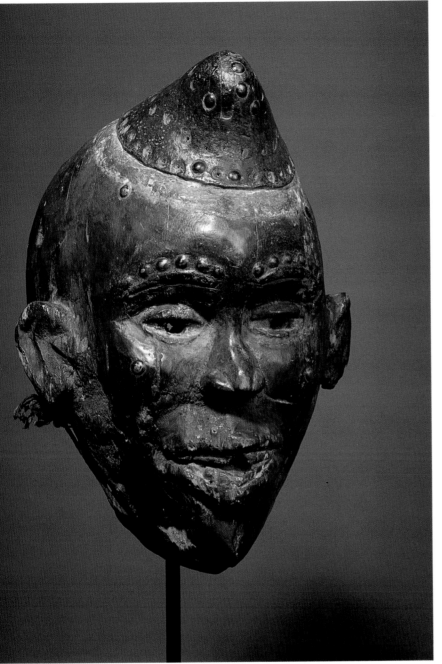

Face mask.
Wood, metal, tacks
Kongo (Vili)
Congo.
Courtesy of the Hemingway African Gallery, New York.

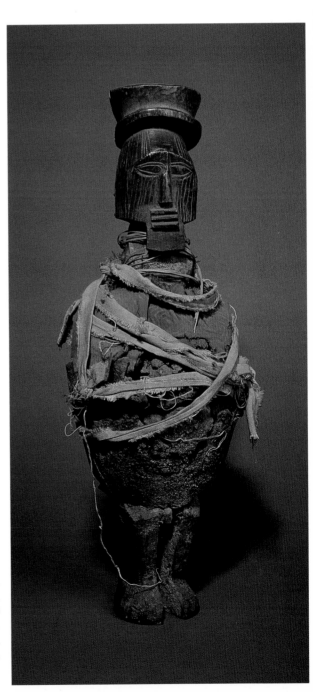

Butti fetish.
Wood, cloth, string, 15".
Teke People
Congo.
Courtesy of the Hemingway African Gallery,
New York.

ANGOLA

Angola finally achieved independence in November, 1975, a decade-and-a-half after most of the African nations, and following a prolonged struggle between competing parties and their foreign allies, including two separate wars for independence in 1961. Independence ended a Portuguese involvement that had begun in 1483 when Diago Cao, a Portuguese explorer, landed there. In 1490, Portugal sent missionaries, workers, and tools to the King of Kongo, who ruled Angola, and received welcome. This changed with the introduction of the slave trade. Relationships with the King worsened, the Kongo Kingdom went into decline, and the Portuguese expanded their contacts along the coast. Angola became the primary source for slave labor on Brazilian plantations.

Today Angola has a population of slightly over 10 million people. The religious distribution is forty-seven percent African religion, thirty-eight percent Catholic, and fifteen percent Protestant.

Based on information from the University of Iowa, Art & Life in Africa project.

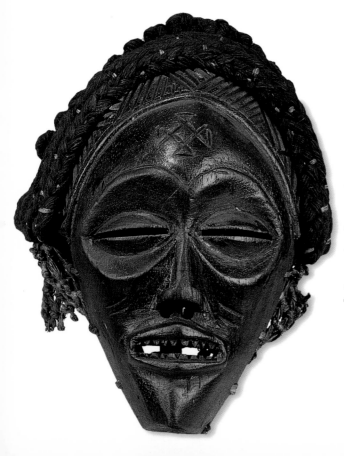

Mwana wa pwo Mukanda men's initiation mask. The mask represents a woman but was worn exclusively by men in male circumcision rites (Segy, *ASS, p. 270*). The scarification mark on the forehead is called *cingelyengelye*. $450-525.
Wood, raffia net, 9" h
Chokwe People
Angola

Pwo mask. $500-550.
Wood, raffia, 7" l
Chokwe People
Angola

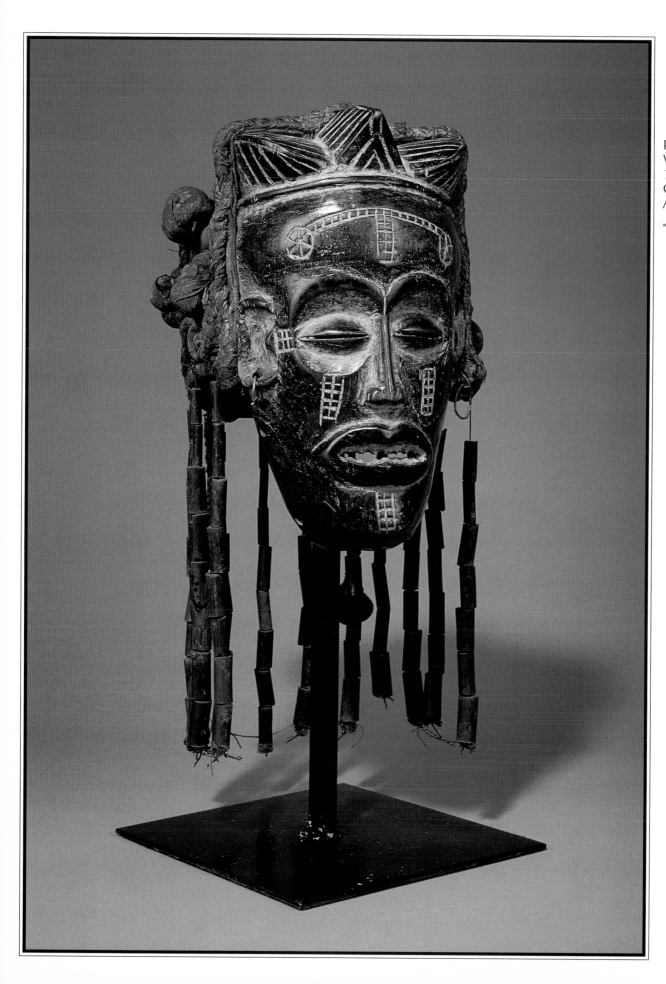

Pwo mask. $425-47
Wood, fiber, beads,
1/2" l (face only)
Chokwe People
Angola.

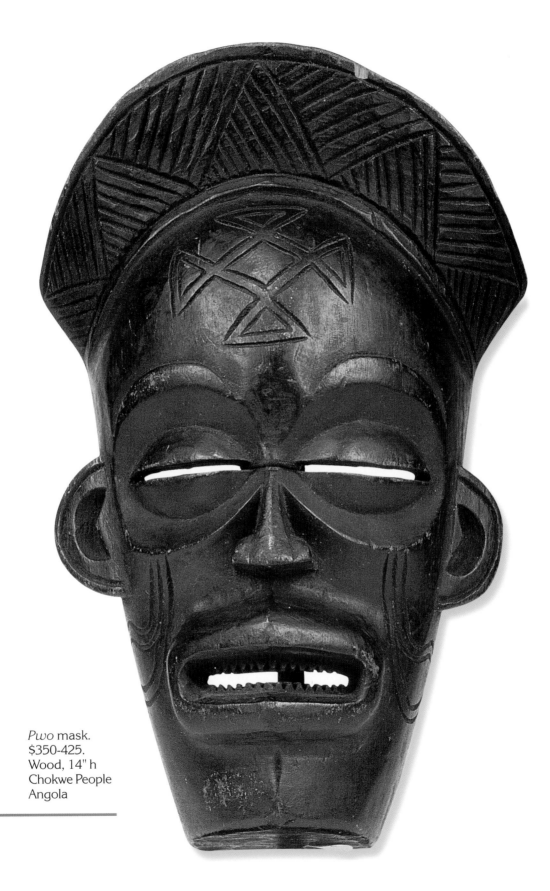

Pwo mask.
$350-425.
Wood, 14" h
Chokwe People
Angola

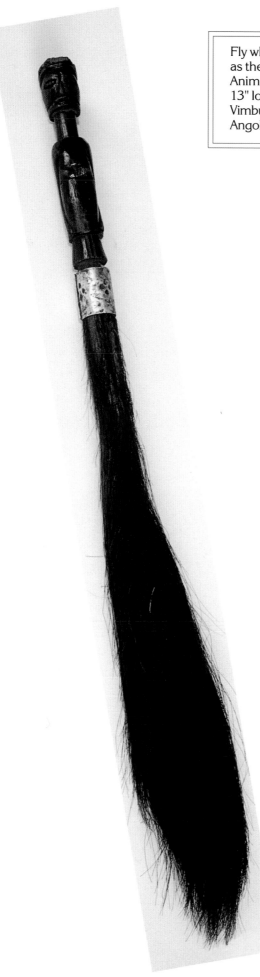

Fly whisk with carved human figure
as the handle. $175-200.
Animal tail, wooden handle, leather,
13" long (overall)
Vimbundu People
Angola

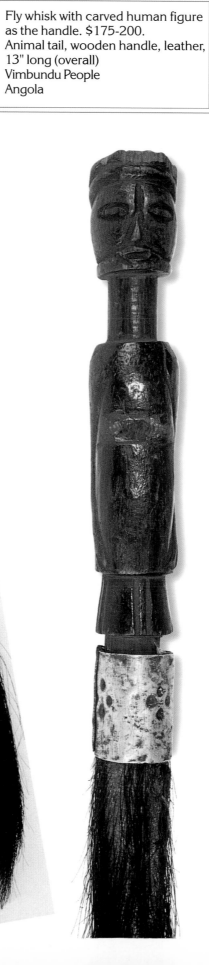

NIGER

Niger is an ancient land with evidence of human habitation dating back to nearly 600,000 years ago. It geographical location made it an important trade center, and thus a center of African culture. The Songhai, Dao, Kanem, Mali, and Bornu empires, and several Hausa states have claimed portions of Niger over the centuries. Contact with the west began in the 1800s and in 1922 Niger became a French colony. Niger became an autonomous French state in 1958 and fully independent in 1960. At present their population tops 9 million. The major peoples are Hausa, Djerrma, Fulani, Tuareg, Beri-Beri, and Gourmance. Eighty percent of the people are Muslim, fifteen percent practice African religions, and five percent are Christian.

Based on information from the University of Iowa, Art & Life in Africa project.

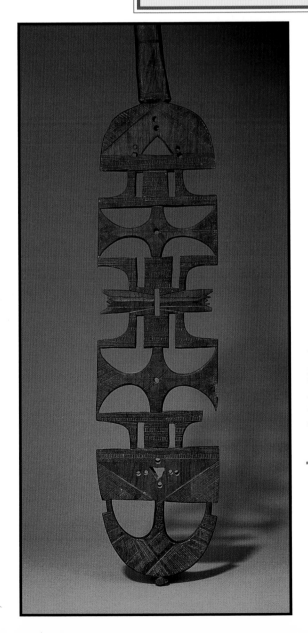

The nomadic people of northern Africa have little use for sculpture per se. Wood is scarce and would be an unnecessary burden as they travel. Their artistry, however, can be seen in other ways, including the decorative tops of their tent stakes. $200-225.
Wood, overall height 47", decorative top piece, 24"
Tuareg People
Niger

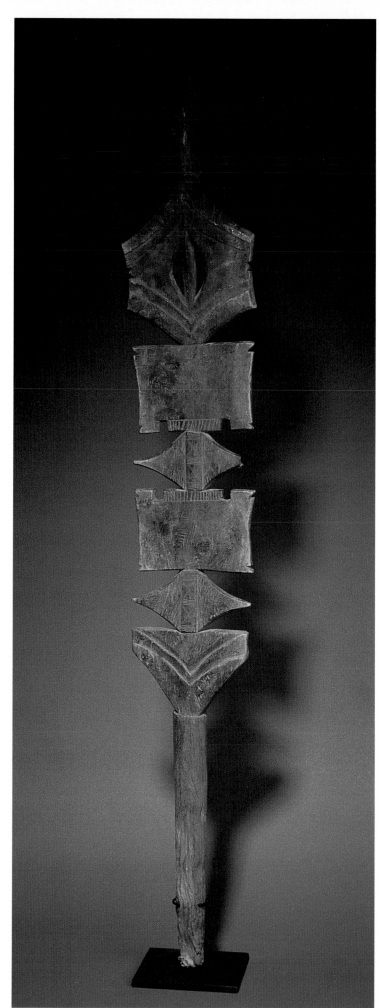

Tent stake.
Wood, 43"
Tuareg People
Niger
*Courtesy of the Hemingway
African Gallery, New York.*

ETHIOPIA

Ethiopia is the only African country to pass through the colonial period without being colonized. Indeed, it has been an independent nation for at least 2000 years. It population of 59.6 million has several main groups including Oromo, Anhara and Tigrean, Shakella, Somali, Afar, and Gurage. Forty-five to fifty percent are Muslim, thirty-five to forty percent are Ethiopian Orthodox Christians, twelve percent are animist, and another three to eight percent follow other faiths, including one of the oldest branches of Judaism.

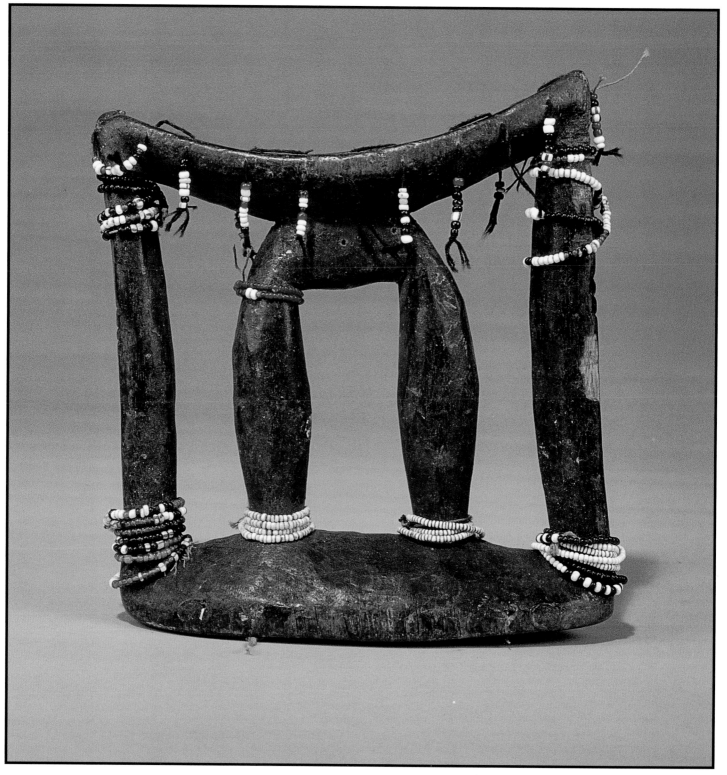

Headrest. $175-225.
Wood, beads, cowries, 7" h
Issa People
Ethiopia

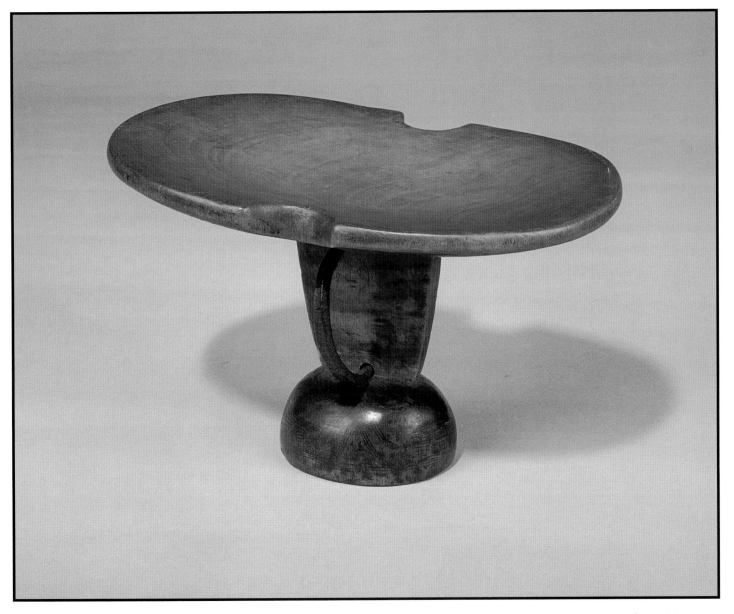

Headrest. $200-225.
Wood, 6" h
Issa People
Ethiopia

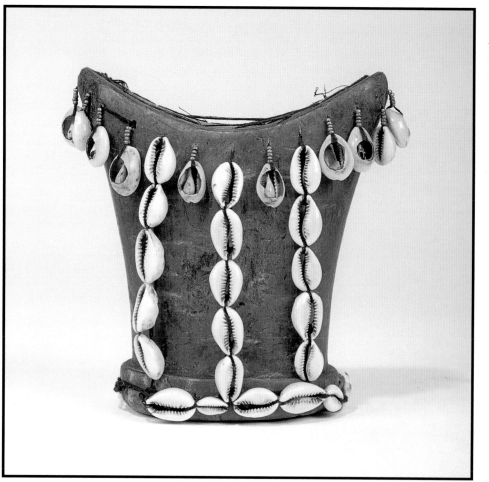

Headrest $200-225.
Wood, cowries, 7" h
Gurago People
Ethiopia

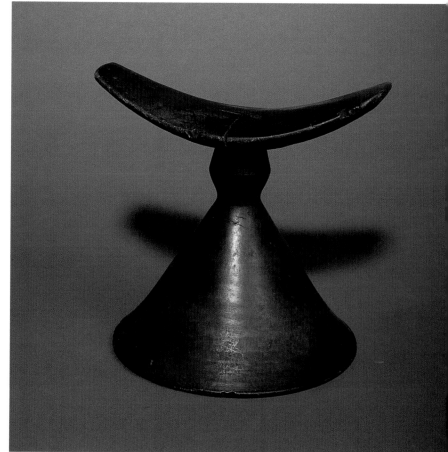

Headrest.
Wood, 18"
Ethiopia
Courtesy of the Hemingway
African Gallery, New York.

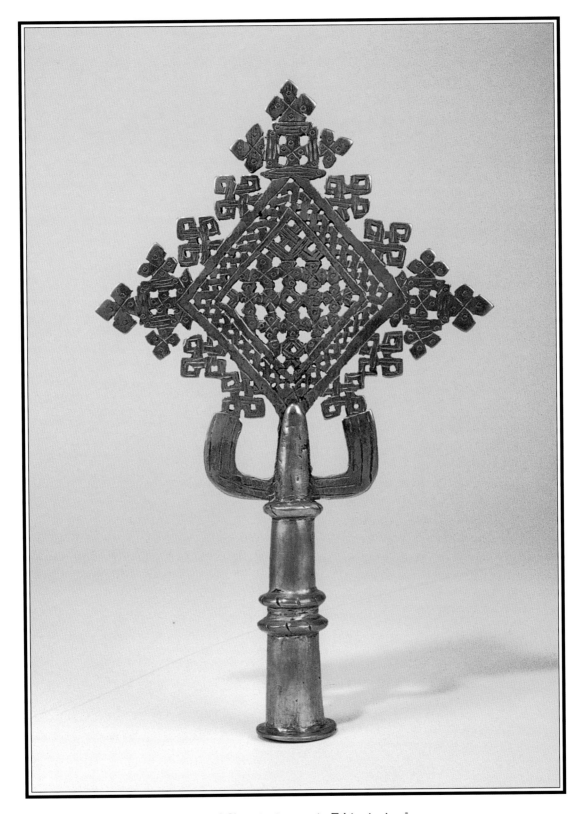

One of the earliest outposts of Christianity was in Ethiopia, in part because of the ancient presence of Judaism. Known as Coptic Christians, they produced some wonderful artifacts, including the Coptic crosses shown here. $200-225
Silver, 11"
Ethiopia

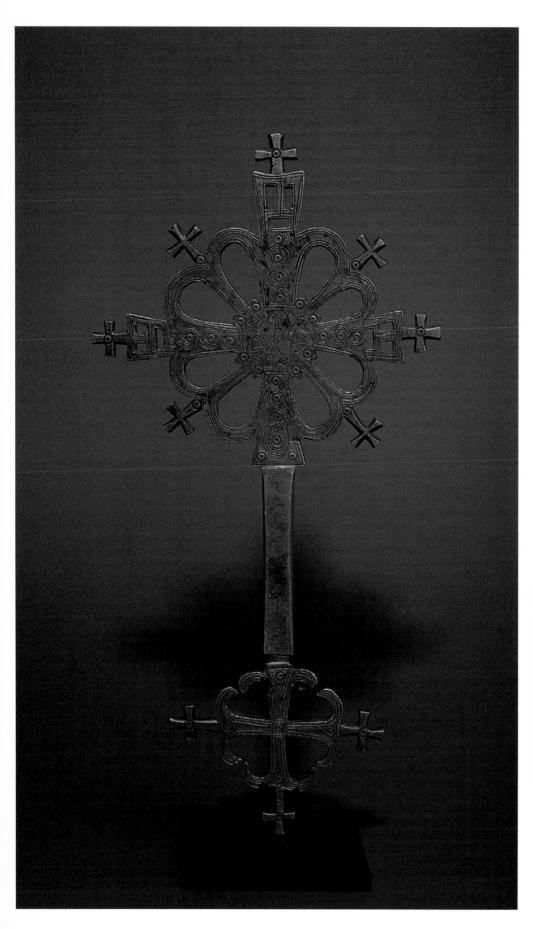

Coptic cross.
12"
Ethiopia
Courtesy of the Hemingway
African Gallery, New York.

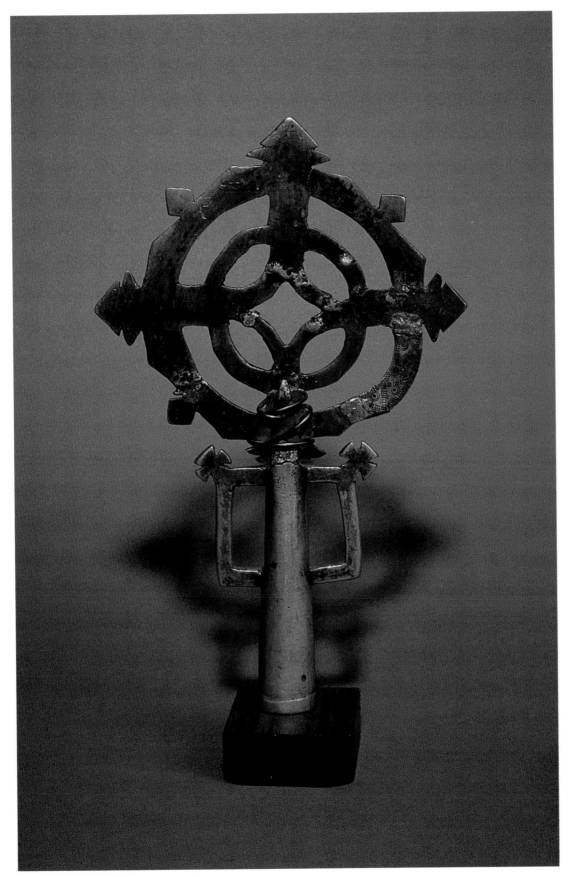

Coptic cross for staff
Brass, 10".
Ethiopia
Courtesy of the Hemingway African Gallery, New
York.

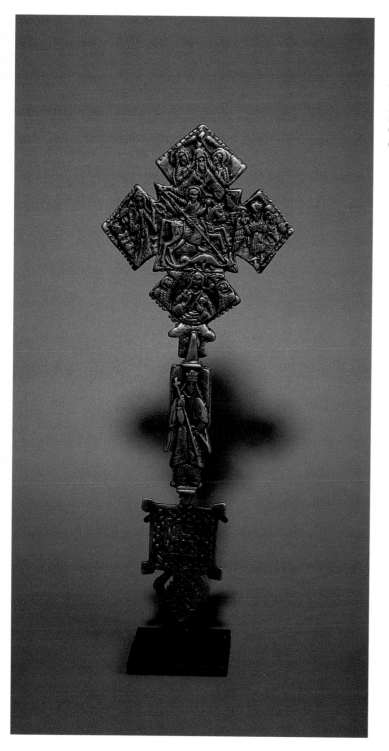

Coptic cross.
Brass, 15"
Ethiopia
Courtesy of the Hemingway African
Gallery, New York.

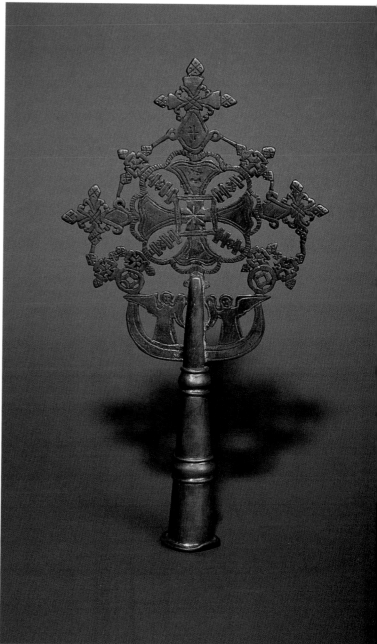

Coptic cross.
Copper and brass, 11"
Ethiopia
Courtesy of the Hemingway African Gallery,
New York.

TANZANIA & MOZAMBIQUE

Formerly known as Tanganyika, the region was probably inhabited by peoples who used a click-tongue language, like the present day Bushmen or Hottentots. Bantu-speaking immigrants and Nilotes largely replaced the early inhabitants, though some isolated remnant people still live there. Its geographical location on the east coast of Africa opened it to contact from all parts of the world. Arab trade existed in the eighth century, and by the twelfth century trade routes were established with India and Persia. European contact came in 1498, when the da Gama explored the region on his way to India. The Europeans were not welcomed and extensive exploration by them waited until the mid-nineteenth century. Germany took a colonial interest in Tanganyika, which lasted until the end of World War I. It became a United Nations trust after World War II, with the British in charge. In 1961, Tanganyika achieved independence and, in 1964, combined with Zanzibar to form the United Republic of Tanzania.

Currently there are nearly 40 million residents. Religiously they are divided almost evenly between African religions, Muslim, and Christianity.

Based on information from the University of Iowa, Art & Life in Africa project.

Mozambique is the southern neighbor of Tanzania. It is about twice the size of California with a population topping 19 million. Major peoples include the Shangaan, Chokwe, Manyika, Sena, and Makua. Fifty percent practice African religions, thirty percent are Christian, and twenty percent are Muslim. Mozambique gained independence from Portugal in 1975.

Small doll, interesting because it is wood covered
in leather, shrunk to a skintight fit. $225-250.
Carved wood, leather, cowries, 6"
Tanzania

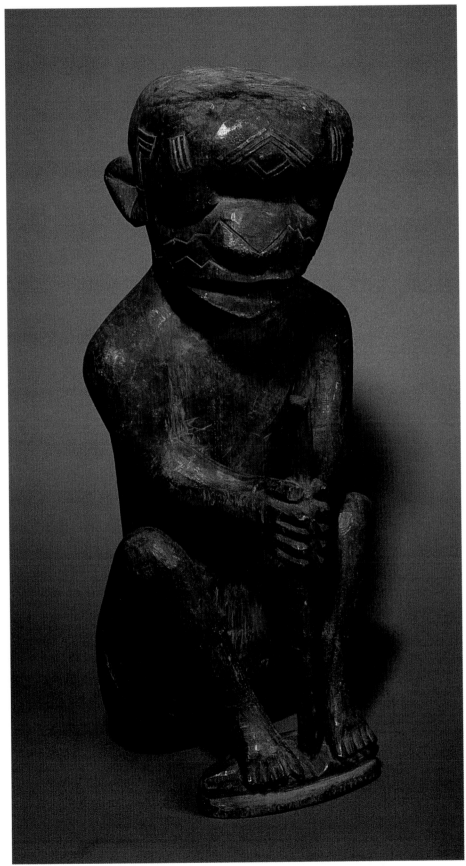

Seated figure statue, showing the facial
scarification common to Makonde
carving.
Wood, 16".
Makonde People
Tanzania

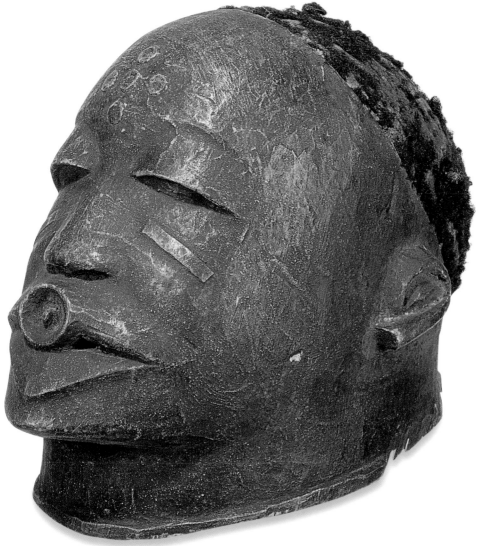

The scarification of this Makonde helmet mask
is typical as are the realistic features. $500-600.
Wood, hair, cork, 11" h
Makonde People
Mozambique

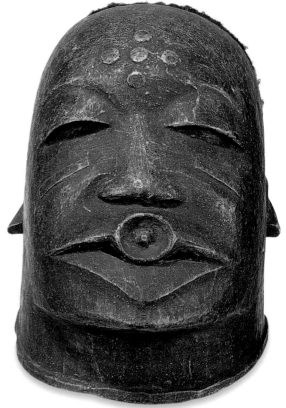

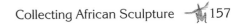

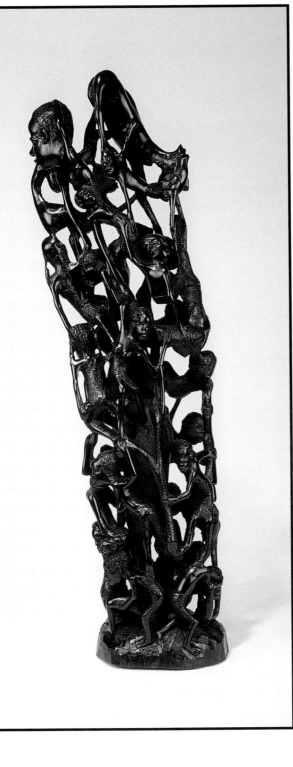

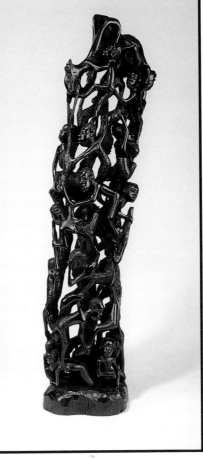

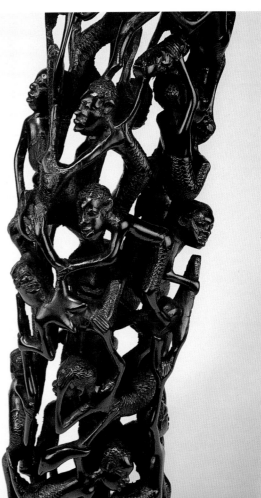

Intricately carved ebony like this family tree is typical of the sculpture being produced the Makonde today. $300-375.
Ebony, 28 1/2" h
Mozambique

ZIMBABWE

Zimbabwe has archeological evidence of human habitation dating back many centuries. The ancient city of Great Zimbabwe shows signs of a complex community with extensive trading contacts. Stone ruins there date from the ninth century to the thirteenth. Except for some failed attempts at colonization by the Portuguese in the 1500s, the country was relatively free of European contact until the 1800s. There were, however, repeated immigrations of Bantu-speaking people, who are the ancestors of today's Zimbabweans. The British took control in the 1890s, renaming the territory Rhodesia, after Cecil Rhodes, the British colonialist. Independence came only through many struggles. Following international pressure that included trade embargoes and other economic sanctions, independence was finally achieved in 1980.

Today Zimbabwe has over 11 million inhabitants, with Shona, N'debele, Xhosa, and Zulu among its major peoples. seventy-five percent are Christian, twenty-four percent Africa religion, and one percent Muslim. The sculptors of Shona are receiving international recognition for their works in stone.

Based on information from the University of Iowa, Art & Life in Africa project.

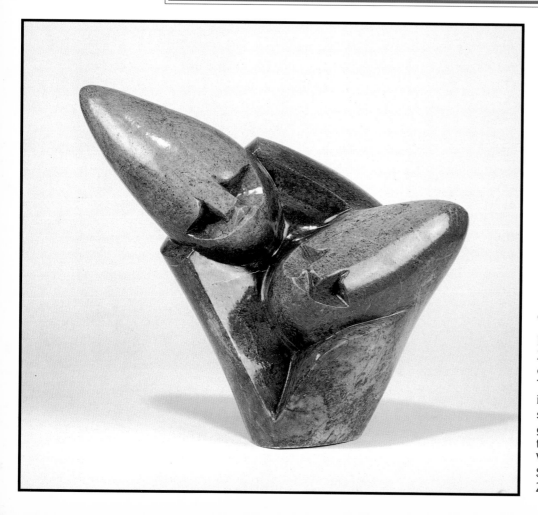

In recent years the Shona People of Zimbabwe have produced a number of highly talented sculptors in stone. Their works have won acclaim in international galleries. This Shona sculpture is but a small taste of a growing body of work being produced today. $625-700.
Verdite, 7-1/2" h
Shona People
Zimbabwe

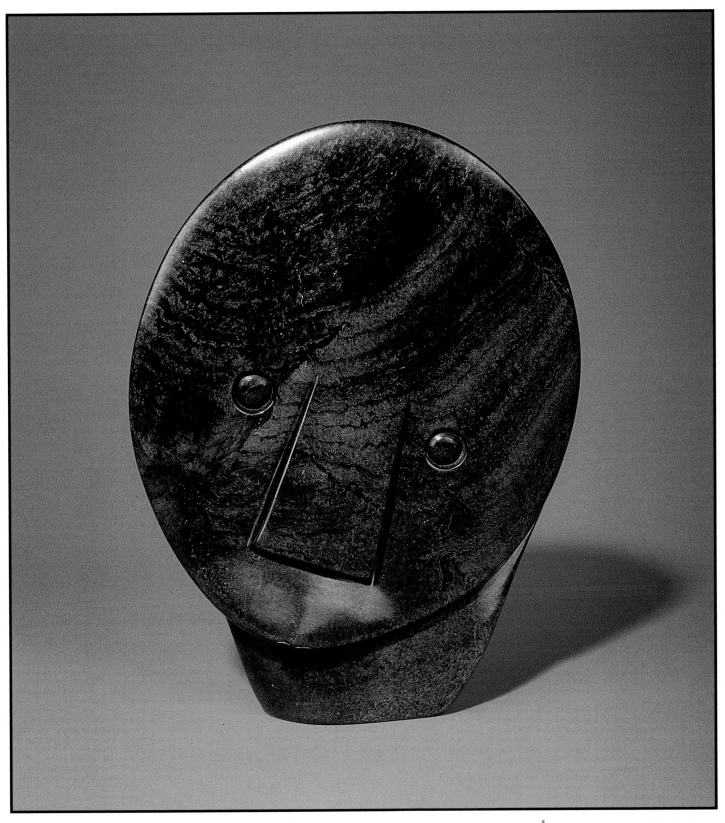

Sculpture, signed Z. Njobo.
$650-700.
Serpentine stone. 11-1/2"
Zimbabwe

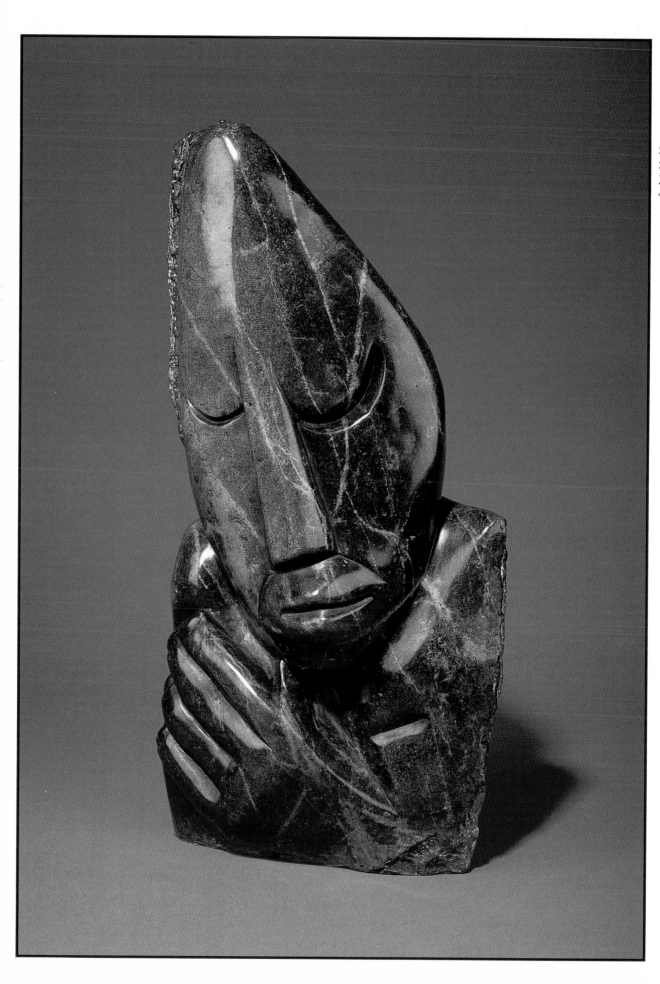

Sculpture. $500-550
Serpentine, 18-1/2"
Zimbabwe